An

AYRSHIRE
Postcard Album

FRANK BEATTIE

AMBERLEY

For Norman, Alan and Matt
my ancient, trusted, drouthy cronies

First published 2011

Amberley Publishing
Cirencester Road, Chalford,
Stroud, Gloucestershire GL6 8PE

www.amberleybooks.com

British Library Cataloguing in Publication Data.
A catalogue record for this book is available from the British Library.

ISBN 978 1 4456 0037 6

Typesetting and Origination by Amberley Publishing.
Printed in Great Britain.

Introduction

The first inhabitants of Ayrshire were nomadic. As the ice age ended, they arrived for the brief, mild summers and clung to the coast. As global warming took effect the winters became more tolerable and eventually there were permanent settlements.

None of these people left much to help us understand them, but some traces from as long ago as 3500 BC have been found. Those early inhabitants soon started to build communities at the places where the rivers flowed into the Clyde Estuary, places we now call Ayr and Irvine.

The centuries rolled by. Hunter-gatherers became farmers and fishermen, exploiting the fertile land and the well-stocked Clyde. They were followed by the industrialists, who took advantage of Ayrshire's generous deposits of coal, ironstone and other minerals.

Ayrshire folk have long been rebels. At Largs in 1263 we fought off the Vikings. Later it was our troublesome neighbours from the south who looked on Scotland with envious eyes, but Ayrshire man William Wallace moulded the people into an efficient force to resist the occupation. After Wallace's murder, another Ayrshire man, Robert the Bruce, took the lead and sent England's King Edward II 'homeward to think again'. Both Ayrshire men helped secure Scotland's independence.

Ayrshire folk were leaders of the Covenanters, those brave souls who fought, and died, for religious freedom in the seventeenth century. And it was Ayrshire folk who helped lead the fight for votes for working men and for women. The British Labour Party owes its origins to an Ayrshire man, James Keir Hardie.

Ayrshire has produced artists, writers, scientists, explorers and builders of new nations. The area was once home to King Coilus of Kyle, who lives on in a universally known rhyme, 'Old King Cole'. Ayrshire is the land of Robert Burns, who taught us that no matter what our origins or beliefs, 'A Man's a Man for a' that' – words that echo across the centuries and are still relevant today.

AN AYRSHIRE GREETING.

" And here's a hand my trusty frien', | And gie's a hand o' thine."

(Compare with John Lennon's 'Imagine'. It is fitting that a piece of artwork in the Burns Birthplace Museum has Burns at the centre of a Da Vinci-style Last Supper, with Lennon as his right-hand man.)

Ayrshire has also been at the forefront of innovation. Scotland's railway revolution started in Kilmarnock with the Kilmarnock and Troon Railway. It was built between 1808 and 1812 to take coal from Kilmarnock to a new harbour at Troon. Even before the line was completed, it had a regular timetabled passenger service, one of the first in the world. It had a steam locomotive early in 1816, the first in Scotland.

Ayrshire is a small county in a small nation and yet the influence of people from Ayrshire can be seen in Canada, the USA, Australia, New Zealand and many other countries.

In this album of Ayrshire postcards, you will find memorials to some of those folk and you will see some of the small rural villages and the great industrial towns.

Frank Beattie
January 2011

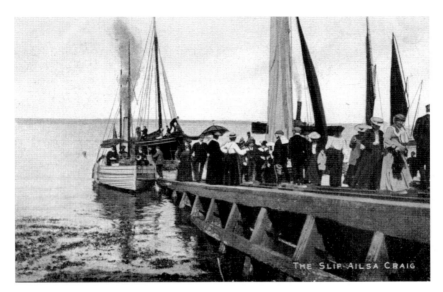

THE SLIP AILSA CRAIG

Ailsa Craig

A round, pudding-shaped island just ten miles from Girvan, Ailsa Craig is an ancient volcanic plug on which the natural granite columns are 1,100 feet high. The island has long been a source of material for curling stones. Occasional trips are still made to quarry new stone. There was a manned lighthouse on Ailsa Craig until 1990, but it is now operated automatically. Today Ailsa Craig is a bird sanctuary.

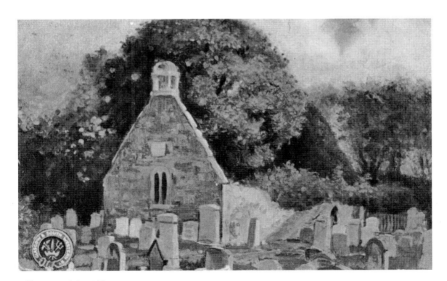

Alloway Kirk, Alloway

Robert Burns lived in the cottage at Alloway until he was seven years old. He remembered the old ruined kirk and used it to marvellous effect as the meeting place of Auld Nick and a coven of witches in *Tam o' Shanter*, which has been described as one of the finest poems ever written in any language. His father, William Burness, is buried in the kirkyard. The ruined church remains an important tourist attraction and is in the care of the National Trust for Scotland.

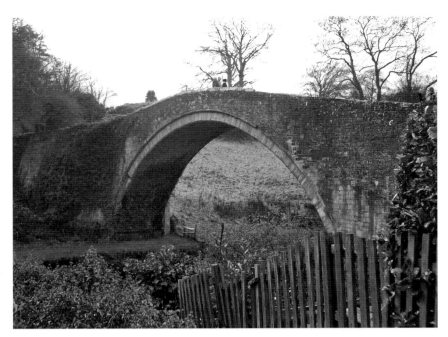

Brig o' Doon, Alloway
This bridge dates from the fifteenth century and was already ancient when Burns knew it as a child. Burns used it in his famous poem *Tam o' Shanter* and because of this connection it has been saved from demolition. Today it is in the care of the National Trust for Scotland.

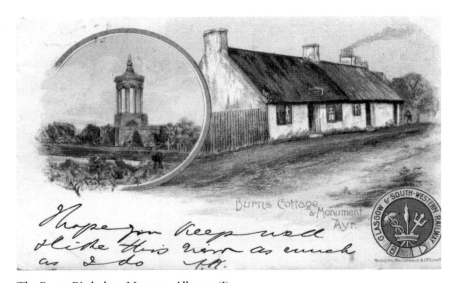

The Burns Birthplace Museum, Alloway (I)
This cottage in Alloway was the birthplace of Scotland's national bard, Robert Burns (1759–96). The cottage was built by Burns' father shortly before Robert's birth. Burns was never the peasant farmer-poet portrayed by some romantics. He was well educated and equally eloquent in Scots and English.

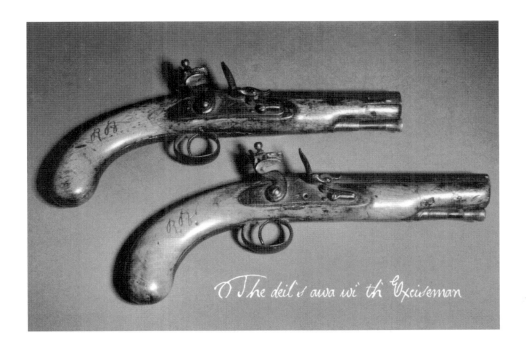

O The deil's awa wi th' Exciseman

The Burns Birthplace Museum, Alloway (II)
The museum was six years in the planning and was officially opened in January 2011. It houses 5,500 artefacts and artworks relating to Burns, including editions of his works in many languages. The uppermost card shows the pistols used by Burns while he worked as an exciseman. The museum also houses the original manuscript copy of *Tam o' Shanter* in Burns' own handwriting and visitors can hear the tale performed.

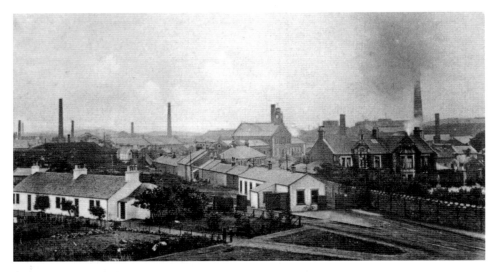

Ardeer

This coastal area was a home for quarrying and ironworks, but it became best known for the Nobel explosive works, set among the sand dunes. Explosives were first made here in 1873 and the complex of factories grew to become the largest producer of dynamite in Europe.

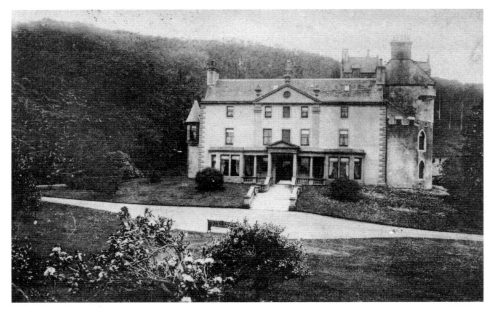

Ardmillan House

The history of Ardmillan House, three miles south of Girvan, goes back to the fifteenth century. It was first owned by the Kennedy family and later owned by the Craufurds. It has been rebuilt and extended on various occasions.

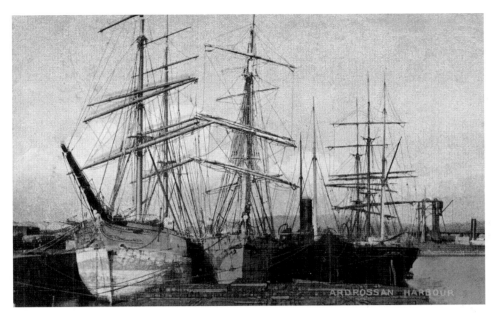

Ardrossan
The town was built on the Ayrshire coast at a point where there is natural deep water, ideal for a port. The beaches here are also particularly fine. Much of the town was planned.

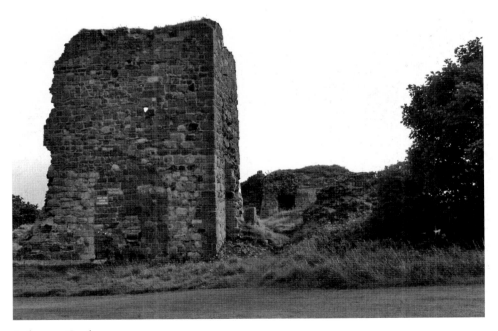

Ardrossan Castle
The ruins are still a dominant feature of the townscape. During the wars of independence, the English army of occupation held the castle, but the fortress was recaptured by the Scots under the leadership of Sir William Wallace.

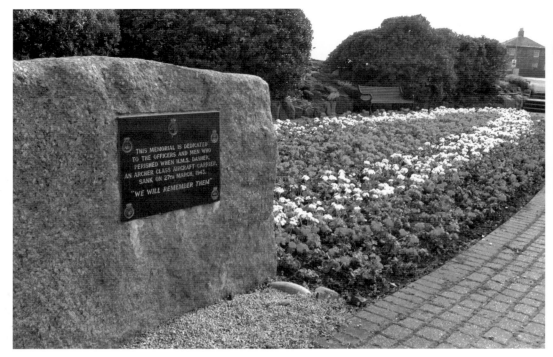

HMS *Dasher* Memorial, Ardrossan

On 27 March 1943, HMS *Dasher* blew up just off the Ayrshire coast, with the loss of 379 lives. Everyone involved – survivors, rescue workers and bereaved relatives – were warned: *never* talk of this incident. And so it remained a state secret for a generation, but now that people like John and Noreen Steele have uncovered the details of the tragedy, a public memorial is in place at Ardrossan shore.

Opposite: **Arran**

Until local government reform in the 1970s, Arran was part of Bute. Because the main link to the mainland was through Ardrossan, it was transferred to Cunninghame District Council, now North Ayrshire Council. It has long been a popular holiday destination. Arran is said to be Scotland in miniature and is so geologically diverse that it is used for training geologists from across the world. From some areas of the mainland you can make out the approximate outline of a human figure lying down and this has given the island its nickname, the 'Sleeping Warrior'.

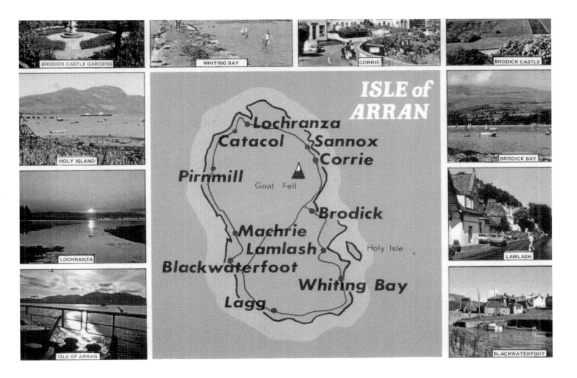

ISLE of ARRAN

Lochranza
Catacol
Sannox
Corrie
Pirnmill
Goat Fell
Brodick
Machrie
Lamlash
Holy Isle
Blackwaterfoot
Whiting Bay
Lagg

BRODICK CASTLE GARDENS · WHITING BAY · CORRIE · BRODICK CASTLE · HOLY ISLAND · BRODICK BAY · LOCHRANZA · LAMLASH · ISLE OF ARRAN · BLACKWATERFOOT

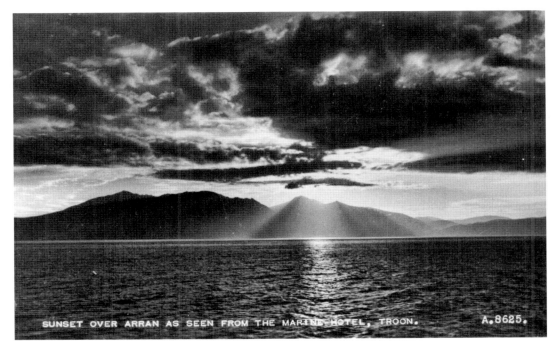

SUNSET OVER ARRAN AS SEEN FROM THE MARINE HOTEL, TROON. A.8625.

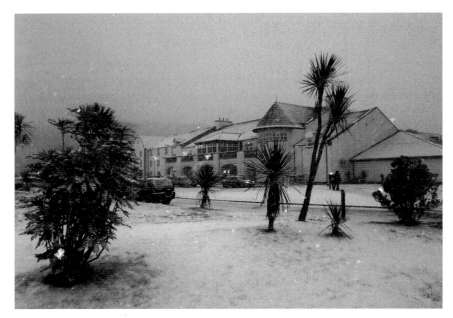

Auchrannie, Arran

This is the one of the premier locations for visitors to the island. Arran enjoys a sheltered climate and places like Auchrannie grow palm trees in their grounds. Occasionally, however, a snow shower will give the palms an unusual touch of white.

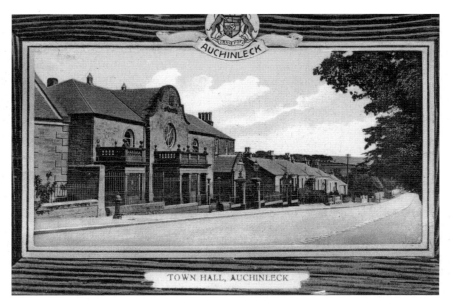

TOWN HALL, AUCHINLECK

Auchinleck

This East Ayrshire town was once a thriving mining community and the local Barony pit was one of the last deep mines in Scotland. The massive A-frame of the pit's winding gear is preserved as a monument. Other industries that have been important here include the production of knitwear.

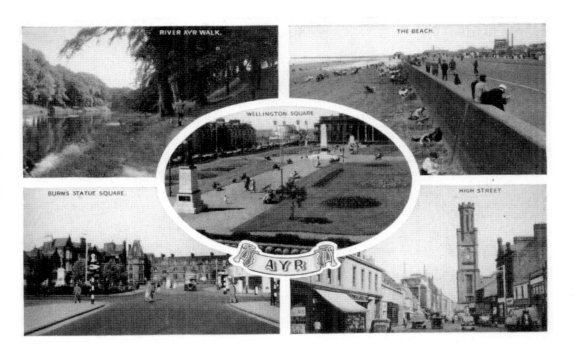

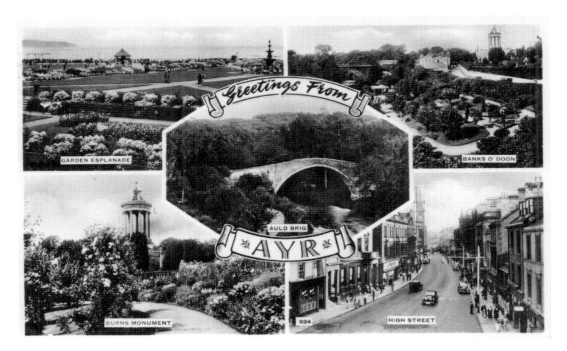

Ayr

In its earliest days, Ayr's location made it a more important port than Glasgow and this importance is reflected in the town's history. The first meeting of the Scottish Parliament to be convened after the Battle of Bannockburn in 1314 occurred in Ayr. Much of Ayr's history reflects the wider history of Scotland.

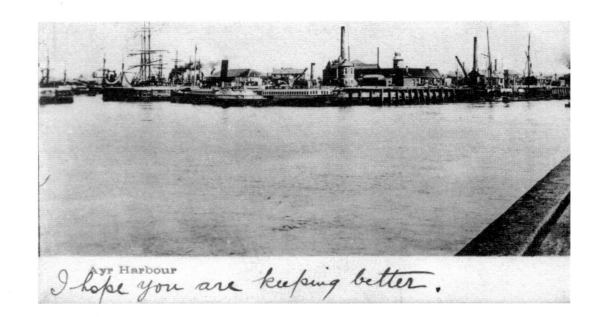

Ayr Harbour

I hope you are keeping better.

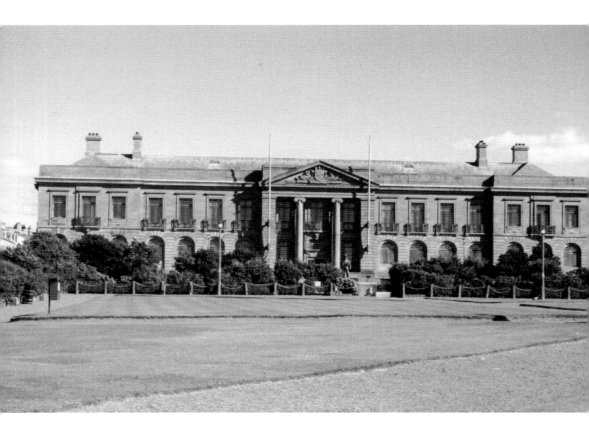

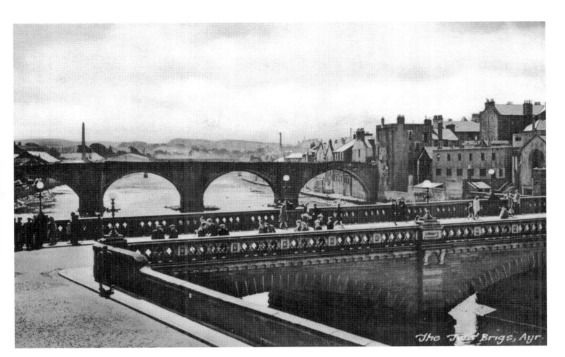

Twa Brigs, Ayr

The town was built at the mouth of the River Ayr, where the natural deep water made it an ideal place for a port. Ayr has the oldest port on the west coast of Scotland, having been granted a charter in 1205.

Opposite: **Harbour and County Buildings, Ayr**

It was probably at Ayr that the earliest nomadic travellers arrived at the end of the ice age. The settlement quickly established itself as the main town in the county and grew steadily in importance, initially because of its easily accessible port and the rich agricultural land around the county.

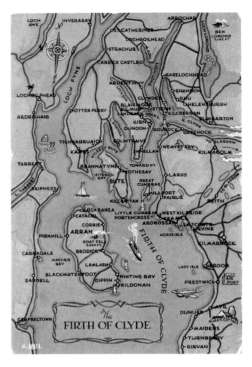

The Ayrshire Coast

In the days before overseas holidays, if families wanted to get away for a holiday, they would have to stay fairly close to home. The Clyde Coast ports shown on the uppermost postcard were popular with people from Glasgow and Ayrshire's towns were all well served by a fleet of steam ships.

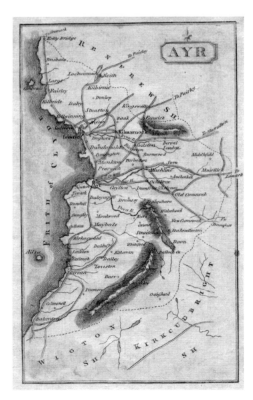

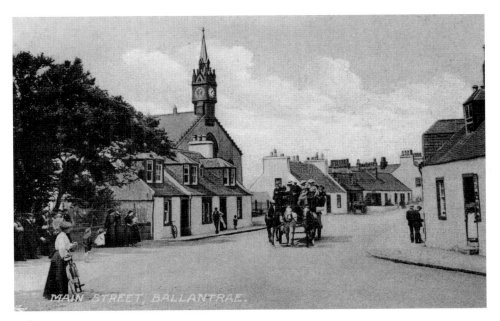

Ballantrae
Built where the Stinchar flows into the water of the Firth of Clyde, the village became a burgh of barony in 1671. The coast at Ballantrae is rugged and at one time almost the entire population was involved in smuggling such highly desirable products as tea and rum.

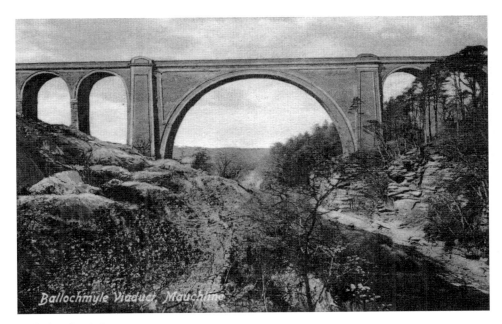

Ballochmyle Viaduct
The viaduct carries the railway over the River Ayr near Mauchline. It was constructed in 1848 and is a magnificent monument to Victorian engineering. There are seven arches, but the central one dominates the bridge.

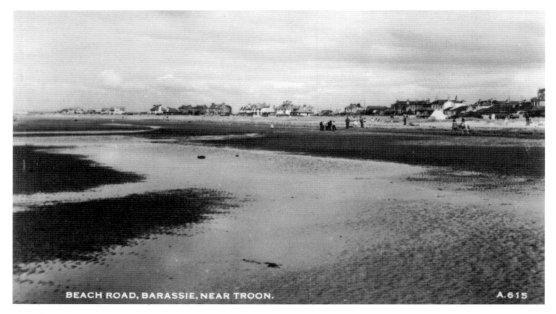

BEACH ROAD, BARASSIE, NEAR TROON. A.615

Barasie

Like Troon, Barassie was largely undeveloped until the start of the nineteenth century, when the Kilmarnock and Troon Railway was built. At the time the authorities tried to give it the name 'New Kilmarnock', but it did not stick. Barassie was a safe haven for smugglers in the eighteenth century. In the early part of the twentieth century, Barassie became important for railway engineering.

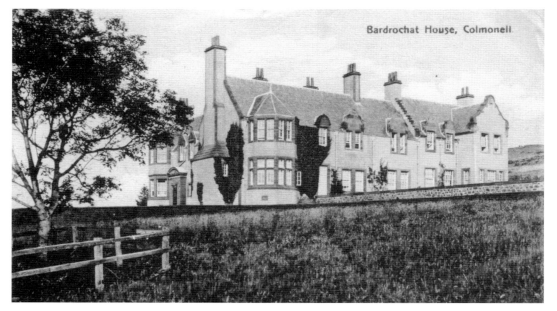

Bardrochat House, Colmonell

Bardrochat

This mansion near Colmonnell was built in 1893 with an extension completed in 1908. It was a family home for many years but it is now a country-house hotel.

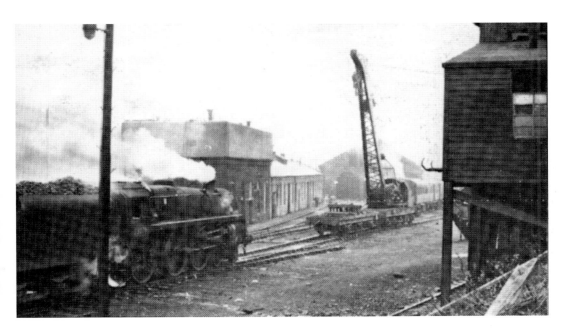

Above: **Barleith**
It was on this site just three miles from Kilmarnock that the Glasgow & South Western Railway Company had extensive railway sheds and works, and it was here that they built houses for their workers. Before that, Barleith was known for mining.

Right: **Barony A-Frame**
Coal mining dominated many of the communities of South Ayrshire. The Barony pit was opened in 1906 and its closure in 1989 devastated local communities. Today the A-shaped winding frame is kept as a memorial. Around it visitors can learn about mining in Ayrshire.

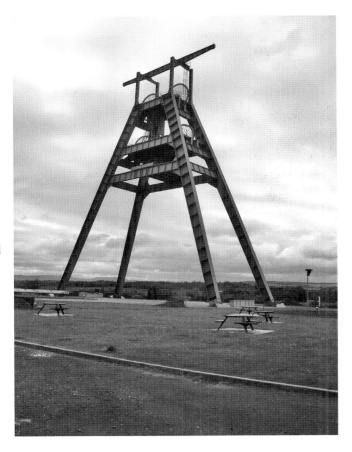

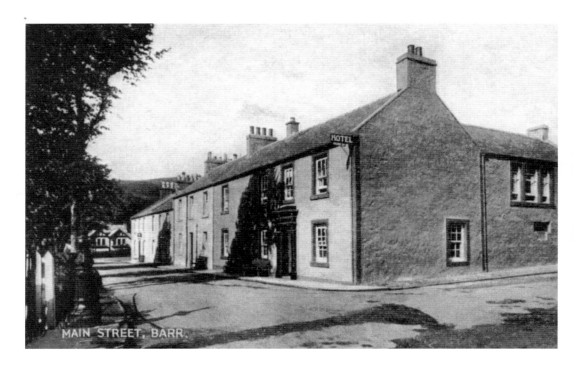

MAIN STREET, BARR.

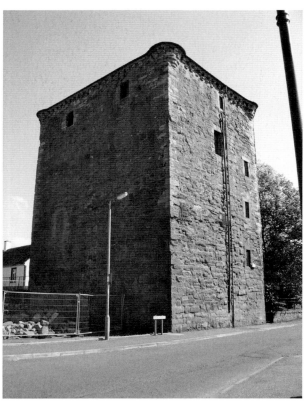

Above: **Barr**

A rural village on the Water of Gregg, Barr is among the hills that mark the boundary between lowland and upland Ayrshire. Like many of the villages of Ayrshire, Barr is steeped in Covenanting history. The village has a memorial fountain to John MacTaggart, who was killed during the Boer War. Farming and forestry are the main industries.

Left: **Barr Castle**

The tower of Barr Castle in Galston dates from the fifteenth century. It has a fascinating history and today the local Masonic Lodge meets here. The building is also used for social functions.

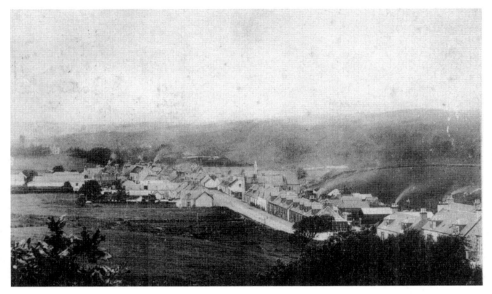

Barrhill
This South Ayrshire village was traditionally the marketplace for the scattered rural population of this part of the county.

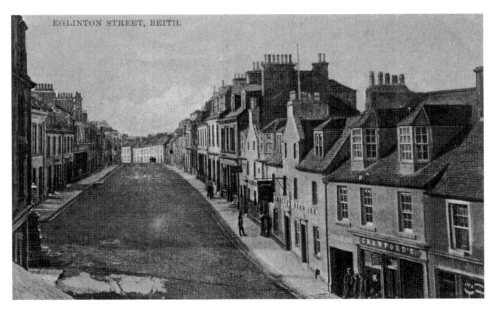

Beith
This North Ayrshire town has been home to various industries, particularly furniture making. It has also been known for the manufacture of golf clubs. At one time many were employed in a nearby armaments depot. Beith was the birthplace of Dr Henry Faulds (1843–1930), the first person to advocate using fingerprints in crime detection. There is a memorial to him in Tsukiji, Tokyo, where he worked for a while as a medical missionary. There is also a memorial in his native Beith.

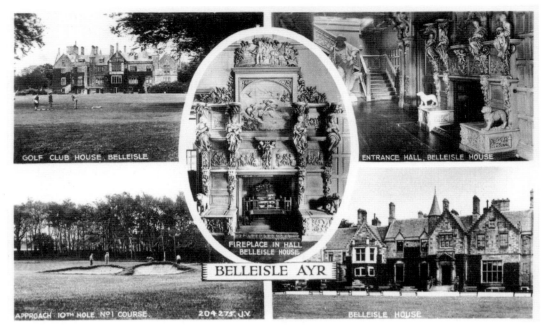

Belleisle

This spot near Ayr is famous for golf. The Belleisle House Hotel has long been popular for weddings and other parties. Just inside the entrance, visitors can see a magnificently carved wooden mantelpiece, which in various panels tells the story of *Tam o' Shanter*.

Cassilis

Pronounced 'cassels', this is one of the finest buildings in Ayrshire. The earliest part was built in the fourteenth century, but there have been many extensions and alterations over the centuries. It is said that the walls of the old tower are 16-feet thick in places. Cassilis has been the property of the Kennedy family since 1373.

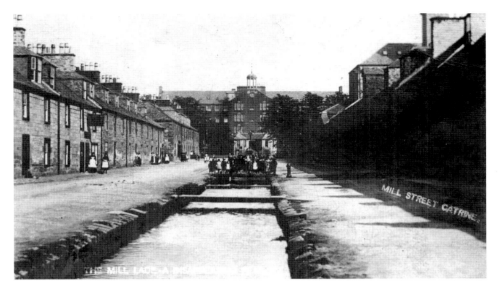

Catrine

This East Ayrshire village was home to one of Scotland's first cotton mills. The grim, functional building is long gone. Ballochmyle is near Catrine. The original Ballochmyle House was often visited by Robert Burns. In the late nineteenth century the citizens of Catrine were woken by the sounds of a bugle. Catrine Voes were created as reservoirs to power the mill. Today they are wildlife sanctuaries managed by a local trust.

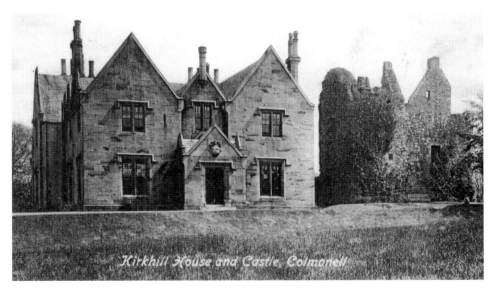

Colmonell

The South Ayrshire village sits on the Stinchar, about five miles inland. There has been a church in Colmonell since the twelfth century, but the present one was built in 1849. The churchyard contains the grave of Matthew McIlwraith, a Covenanter who was shot dead at the order of John Graham of Claverhouse. Two more martyrs from Colmonell are buried at Barrhill; there is a monument to them at the entrance to Colmonell.

Coodham House

This nineteenth-century mansion sits between Kilmarnock and Symington. It was built around 1830 and was extended in 1847 to include a chapel and a stable court. The chapel boasts excellent craftsmanship in oak, glass and marble. The grounds are extensive and in recent years houses have been built here.

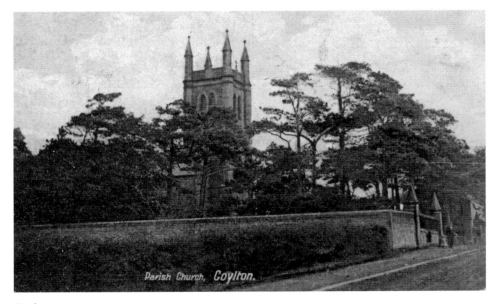

Parish Church, *Coylton.*

Coylton

This South Ayrshire village owes its existence to two industries, farming and coal. Traditionally, one part has been called Hillhead and the other Joppa. The village retains the ruin of a church, which was abandoned when a replacement was completed in 1836. The old kirkyard has some interesting gravestones.

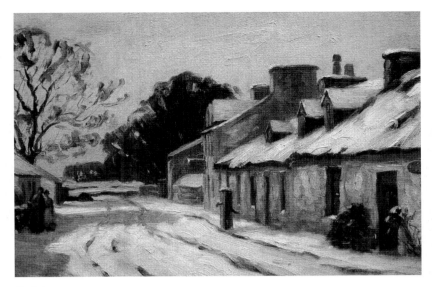

Craigie

This painting is *Craigie Village in Winter* by John Watson (1863–1928). It is in the art collection of the Dick Institute in Kilmarnock. Although just three miles from Kilmarnock, Craigie sits among rocky hills. The inn here is very old but enjoys a good reputation.

Craigie Castle

This twelfth-century fortification was once the most magnificent castle in Ayrshire. It belonged to the Lyndesay family and passed into the ownership of the Wallaces of Riccarton through marriage. The Wallaces occupied the castle until they moved to Newton-upon-Ayr in about 1600, leaving their once-magnificent castle to fall into ruin. The Wallaces were a very powerful family and some had distinguished military careers. John Wallace of Craigie was lieutenant general to James II of Scotland, and fought with distinction at the Battle of Sark in 1447.

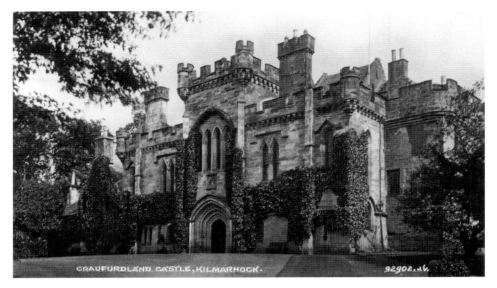

Craufurdland Castle

The Craufurds of Craufurdland have occupied the castle near Fenwick since the start of the thirteenth century. The present structure shows three distinct construction phases. The main part of the front, with its gothic entrance, was built in 1825. The section to the left of this was added in 1648 and the part to the right was built in the fifteenth or sixteenth century, possibly on the site of an earlier structure.

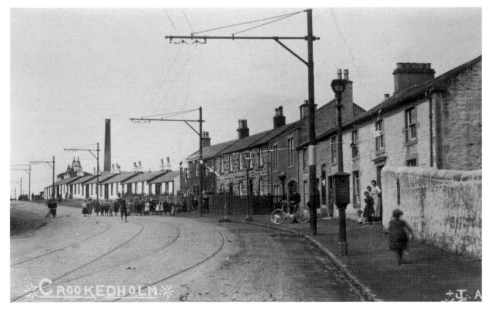

Crookedholm

This East Ayrshire village lies between Kilmarnock and Hurlford on the River Irvine. It was largely a mining community. Today Hurlford and Crookedholm are almost absorbed into the urban sprawl of Kilmarnock.

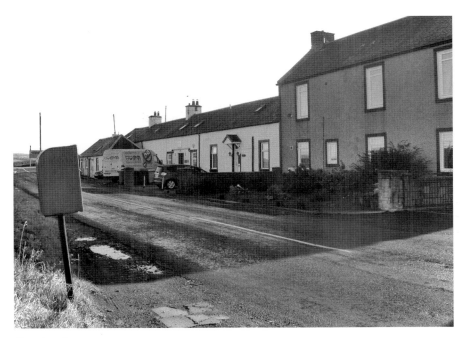

Crosshands

This little community sits near Mauchline, where the Tarbolton–Galston road crosses the Kilmarnock–Dumfries road. In former days, the hamlet was on the coaching route that carried traffic between Glasgow and Dumfries. Crosshands had an inn that was popular with travellers.

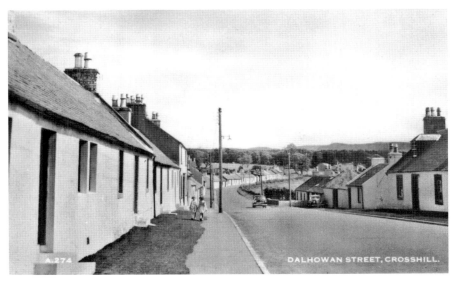

DALHOWAN STREET, CROSSHILL.

Crosshill

This South Ayrshire village lies on the road between Maybole and Dailly, about three miles from Maybole. Crosshill is one of the few rural communities that retains the charm and character of its former days.

Crosshouse

This East Ayrshire village has a long tradition of mining and a local miner, Andrew Fisher, became a trade union leader then a politician. He migrated to Australia and became the first Labour prime minister of Australia. Today Crosshouse is largely a suburb of Kilmarnock and is home to the general hospital for north and central Ayrshire. It was in this hospital in 1989 that a team headed by Dr Raj Singh performed Scotland's first cochlear implant. It was, in fact, one of the earliest such operations in the world.

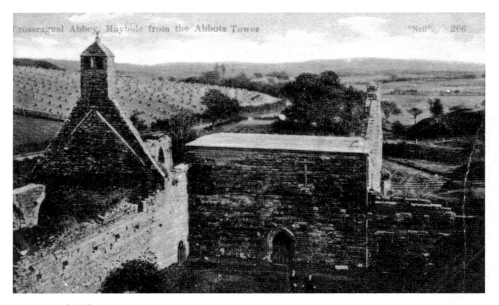

Crossraguel Abbey

The Abbey of Saint Mary of Crossraguel has its roots in the middle of the thirteenth century when it was established by the monks of Paisley Abbey at the request of Duncan, Earl of Carrick. The abbey lasted for several centuries but was a ruin by the close of the seventeenth century. The Kilkerran family did much to preserve the ruins and today they are in the care of Historic Scotland.

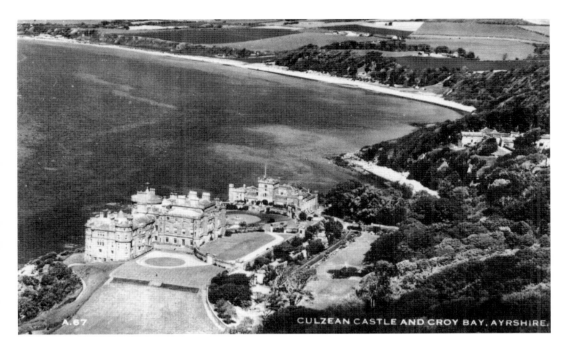

CULZEAN CASTLE AND CROY BAY, AYRSHIRE.

Culzean Castle

Culzean Castle & Country Park is on the coast near Maybole. The modern Culzean Castle was designed by Robert Adam in the eighteenth century. Today the castle and the grounds form the jewel in the crown of the National Trust for Scotland. The castle houses important collections of arms and furniture and the associated buildings and grounds offer something for every visitor. The grounds are popular with visitors throughout the year.

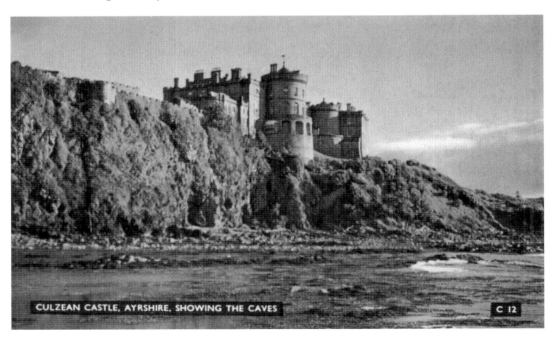

CULZEAN CASTLE, AYRSHIRE, SHOWING THE CAVES

C 12

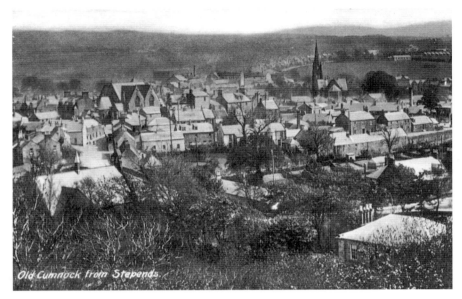

Cumnock

This old East Ayrshire community was awarded burgh of barony status in 1509. The town relied on farming and other local resources, but it was the local coal mines that produced the town's most famous son, James Keir Hardy (1856–1915), the founder of the Labour Party. He was born in Lanarkshire and by the age of seven he was an errand boy. By ten he was working in the coal pits. He lived in Cumnock from 1879 until his death.

Cunninghamhead

The railway junction near the hamlet of Dykehead has now gone, but the hamlet has now taken its name, Cunninghamhead. It remains a small hamlet where the road from Kilmaurs to Kilwinning meets the road from Irvine to Stewarton.

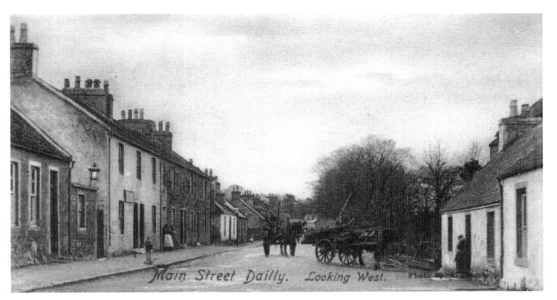

Main Street Dailly. Looking West.

Dailly

Built on the River Girvan about three miles from the original hamlet of that name, Dailly was, in former times, largely a mining community, but there are no deep mines in the area now. The original Dailly retains the ruins of the old parish church.

Dalleagles

This East Ayrshire village is not what it used to be. There was once a school and an inn to serve the rural community, but today it consists entirely of houses.

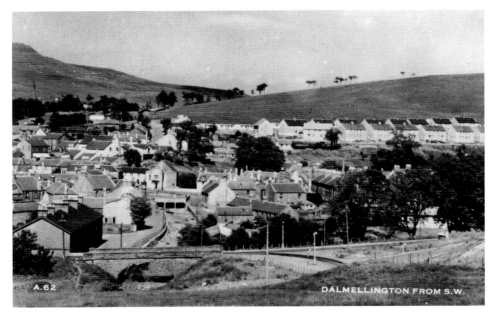

Dalmellington

One of the larger settlements in this part of South Ayrshire, Dalmellington was originally a coal mining town, and today there is an open cast mine. Dalmellington sits on the boundary of the lowlands and the southern uplands and here the landscape changes dramatically. There is an ancient motte – a huge manmade mound of earth.

Dalry

Much of this North Ayrshire town dates from the eighteenth century, when Dalry flourished thanks to the textile trade and, later, coal, iron and brickmaking. Today the town is dominated by the Roche works, which started making artificial vitamins here in 1950.

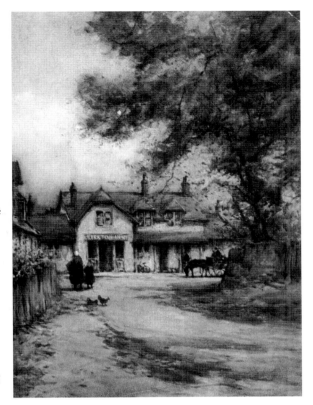

Right: **Dalrymple**
Fairly typical of the villages of South Ayrshire, Dalrymple lies on the banks of the River Doon and is backed by steep hills. The main street has changed little over the years and many of the attractive buildings here date from the eighteenth century.

Below: **Dankeith**
Although Dankeith House near Symington has a date stone for 1893, some parts are much older than that. It was originally a private residence. During the Second World War Dankeith was used by the RAF and for secret meetings in the planning of D-Day and other key operations. It was the home of the Passionist Fathers around 1948–68.

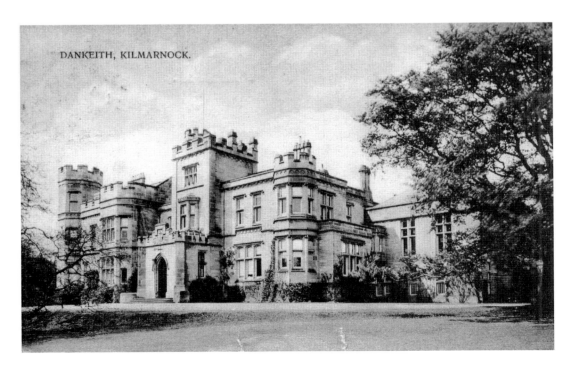

DANKEITH, KILMARNOCK.

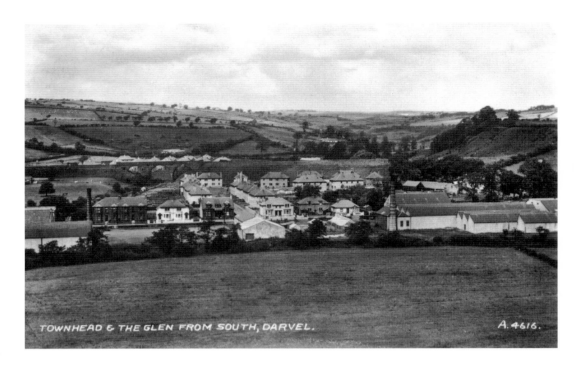

TOWNHEAD & THE GLEN FROM SOUTH, DARVEL. A.4616.

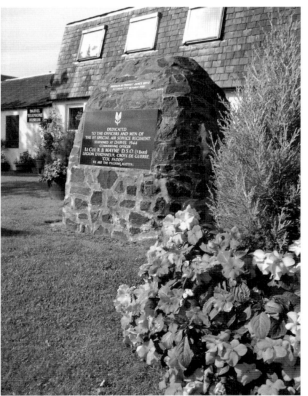

Above: **Darvel**
This East Ayrshire town sits at the head of the Irvine Valley and for many years it was famous for the production of lace and other textiles. It was an industry that employed 1,800 people.

Left: **SAS Memorial, Darvel**
Ayrshire was home to a secret army during the Second World War. It was here that men from the SAS trained and it was in Ayrshire, at the start of 1944, where the SAS was brought up to brigade strength. The community of Darvel has remembered those brave men with a community memorial.

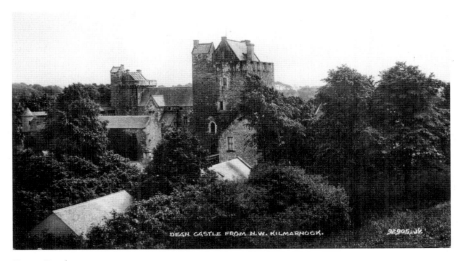

Dean Castle

History is vague on Dean Castle but we do know that from the twelfth century it was the seat of the feudal lords of Kilmarnock. From the late thirteenth century, the castle was the seat of the Boyd family, who fought at the Battle of Largs and with Robert the Bruce in the Wars of Scottish Independence. The castle was substantially damaged by a fire in 1735 and fell into ruin, but it was restored in the first half of the twentieth century. In 1975 the castle and its internationally important collections of arms and musical instruments were given to the people of Kilmarnock. It is now the area's top tourist attraction.

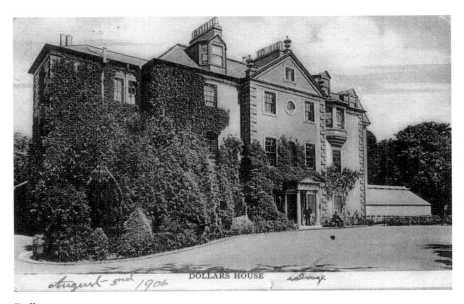

Dollars

Dallars House, sometimes referred to as Dollars, sits by the River Cessnock near Fiveways, and was constructed on the site of an older building. Part of the stable cottages dates from 1635. The rest of the building was erected in 1779. It is still occupied. In recent years the house and grounds have been home to a riding school for the disabled.

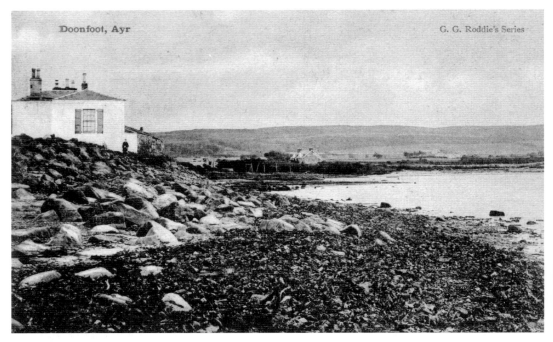

Doonfoot

This South Ayrshire village was originally a small group of houses at the mouth of the River Doon. Today, it is an area of housing developments and has been absorbed into the urban area of Ayr.

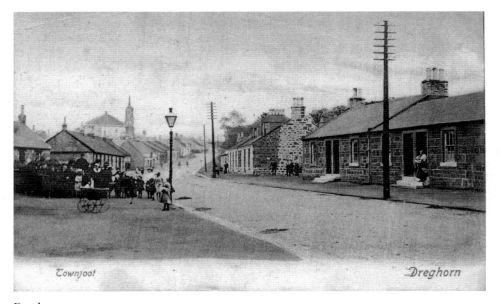

Townfoot

Dreghorn

Dreghorn

This North Ayrshire town sits on the route from Kilmarnock to Irvine and had its origin in farming and coal mining. Dreghorn Church is a distinctive octagonal building. Dreghorn was the birthplace of John Boyd Dunlop (1840–1921), who invented the pneumatic tyre.

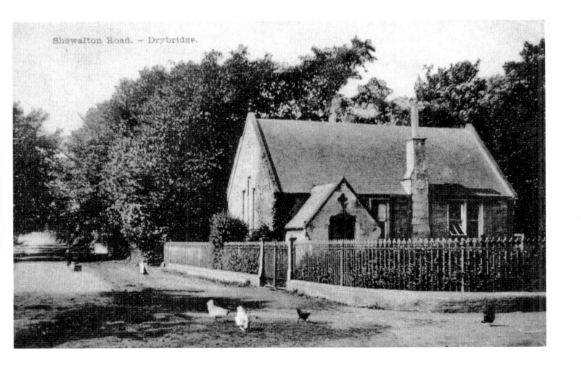

Right: **Drumclog**

This Lanarkshire village lies just across the county boundary, but it played an important part in Ayrshire history. In 1679 there was a battle (well, a skirmish) between the Covenanters and the authorities in Drumclog. The result was an important victory for the Covenanters, who were seeking religious freedom. Many of those involved came from Ayrshire.

Below: **Drybridge**

The small community of Drybridge takes its name from the bridge built over the Kilmarnock and Troon Railway. The railway was built between 1808 and 1812. In the early days of the railway some of the horses required to pull waggons were stabled here.

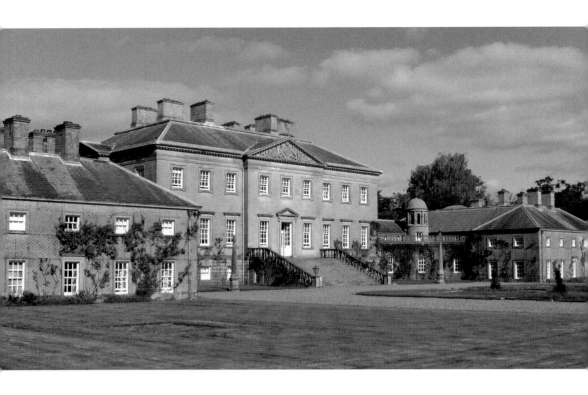

Dumfries House

Dumfries House near Cumnock was a private residence until 2007, when plans were put in place to sell the house and its furniture. The Scottish Government and East Ayrshire Council worked to save the estate, building and contents for the nation, and this was achieved, but only with the personal intervention and dedicated support of Prince Charles. The house, now open to the public, contains a unique collection of furniture from the pre-eminent Scottish furniture makers of the mid-eighteenth century, as well as some of the earliest furniture made by Thomas Chippendale.

Opposite: **Dunaskin**

Also known as Waterside, Dunaskin grew to serve the Dalmellington Ironworks site, established here in 1847. At its peak the business employed 2,000 and had eight furnaces. After closure in 1921 the site became a brickworks, which in turn closed in 1976. Plans to turn the site into a major open air museum faltered because of lack of funds, but volunteers of the Ayrshire Railway Preservation Group operate their museum here with occasional 'steam days'. The postcard below shows one of the former National Coal Board locos, now preserved. It was originally built in Kilmarnock by Andrew Barclay Sons & Co.

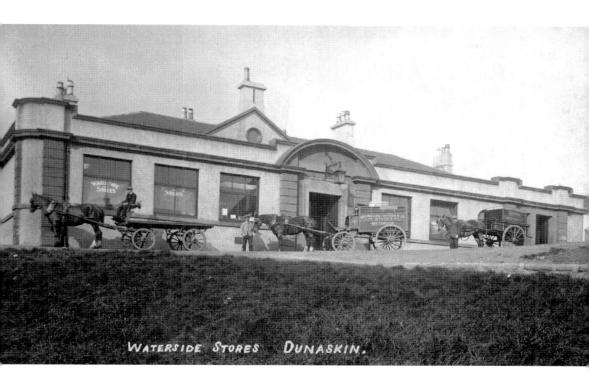

WATERSIDE STORES DUNASKIN.

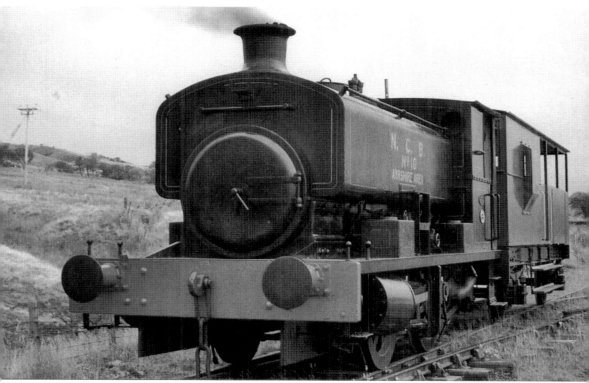

Dundonald

An ancient community based largely on farming, this South Ayrshire village grew around the local castle, which dominates the local landscape. Dundonald's main street retains a mix of residential and commercial properties and is largely unspoiled by modern development.

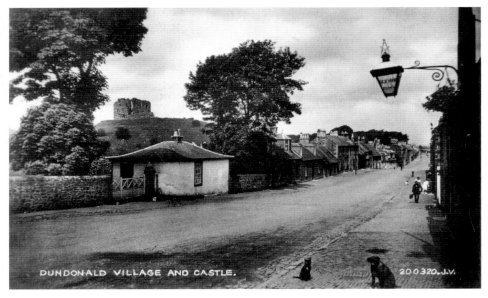

DUNDONALD VILLAGE AND CASTLE. 200320.J.V.

Dundonald Castle

This fourteenth-century fortification sits on a hill on a site that has been occupied for over 4,000 years. A settlement became a fort, which then became a castle, which in turn became a royal residence. It was here that Robert II of Scotland held court. He died here in 1390. The castle was allowed to fall into ruins, but in the hands of Historic Scotland it has been partially restored and is now open to the public.

Above: **Dundonald Glen**
This valley has long been a popular area for walkers and ramblers. In former days it was the route used by smugglers bringing goods from Troon to inland communities such as Dundonald and Kilmarnock. Today it forms part of the Smugglers' Trail.

Right: **Dunlop**
Barbara Gilmour started making a new kind of cheese in this East Ayrshire village at the end of the seventeenth century and Dunlop cheese was soon known all over the country. Dunlop's church dates from 1835, but it was built on the site of a much older church.

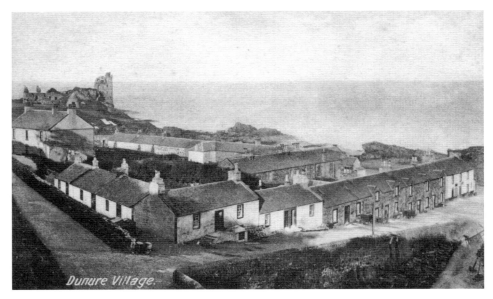

Dunure

This South Ayrshire village developed as a fishing port about six miles south of Ayr. As well as the port, the village also boasts Dunure Castle. The coast here throws up a variety of fine gemstones and the area remains popular with people who have an interest in lapidary.

Eglinton Castle

Little remains of Eglinton Castle today. The name Eglinton goes back to the eleventh century and the connection with the Montgomery family to 1508. The castle was built between 1796 and 1802. It was in use until about 1925 and during the Second World War it was used by the commandos for demolition training.

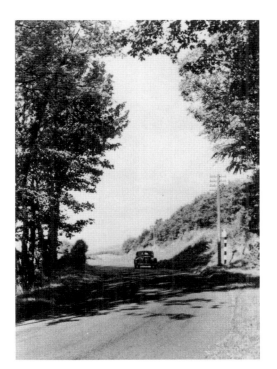

The Electric Brae

A short stretch of the A719 near Croy is known as the Electric Brae. Motorists feel they are driving down a gentle slope, but are actually going uphill. Conversely, drivers travelling in the opposite direction see that they are going uphill, yet the vehicle seems to want to freewheel. The strange effect is caused by... or would it spoil the fun to give the simple truth?

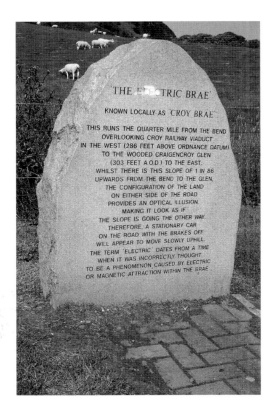

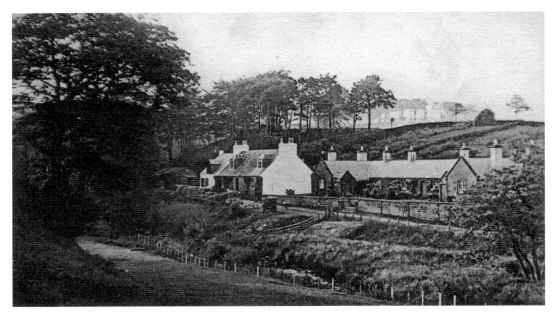

Failford

This hamlet is the remnant of a once powerful community based around the ancient Monastery of Fail. It was founded in 1252 by John de Graham, Lord of Tarbolton, and was run by the Red (or Trinity) Friars. The monastery lasted until the early years of the seventeenth century.

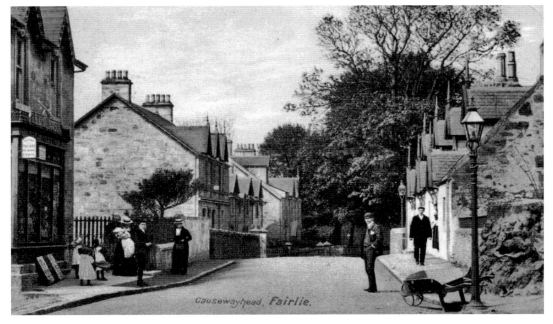

Causewayhead, *Fairlie*.

Fairlie

Boats were once built at this fishing port, which grew rapidly after being connected to the railway network in 1880. After the Second World War, NATO had a base near here for a number of years.

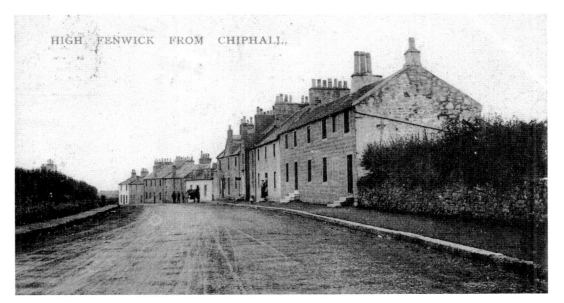

High Fenwick

Traditionally there are two Fenwicks. High Fenwick had the cobblers, the school and the kirk. This was the birthplace of John Fulton (1800–52). He was a cobbler who became an instrument maker and is best remembered for building what was regarded as the world's greatest orrery (i.e. a mechanical representation of the solar system with its various planets and moons).

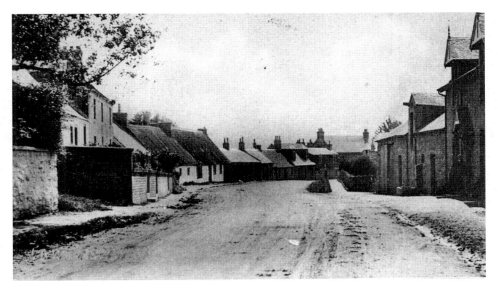

Laigh Fenwick

Fenwick parish was part of the parish of Kilmarnock until 1642. Traditionally, Laigh Fenwick's main industry was weaving. Fenwick people were strong supporters of the Covenanters. There was always good-natured rivalry between the two Fenwicks. One chap praising High Fenwick argued, 'We've got the kirk and the school.' His friend from Laigh Fenwick responded, 'Aye, they're whaur they're needed.'

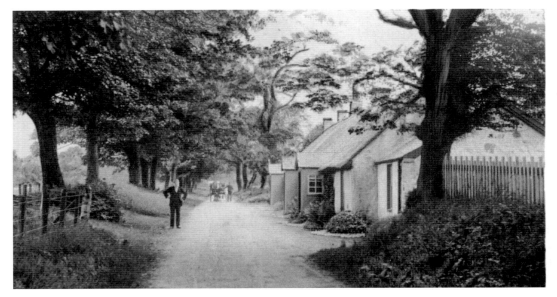

Fullarton

Today Fullarton is an area of Irvine, but at one time it was a separate burgh. The community achieved burgh status in 1707. Other than the parish church building, much of what had been Fullarton is taken up with car parking between Irvine's shopping centre and the railway station.

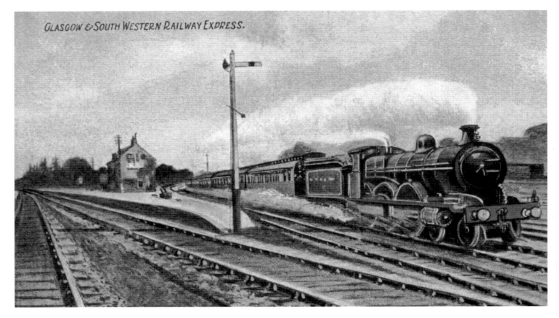

GLASGOW & SOUTH WESTERN RAILWAY EXPRESS.

G&SWR

The Glasgow & South Western Railway was formed in 1850 when several smaller railway companies merged. G&SWR dominated railway services in Ayrshire until the grouping in 1923 which saw the emergence of the London, Midland and Scottish Railway (LMS). From 1856, G&SWR had its main engineering works in Kilmarnock.

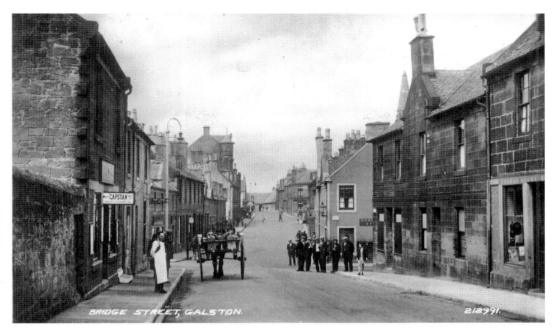

Galston

An ancient community that had a church in the middle of the thirteenth century, Galston prospered thanks to farming and weaving. Later it was mining that came to dominate the community. Galston became a police burgh in 1864 and it had its own town council until local government reform in the 1970s. The oldest building in Galston is the fifteenth-century Barr Castle.

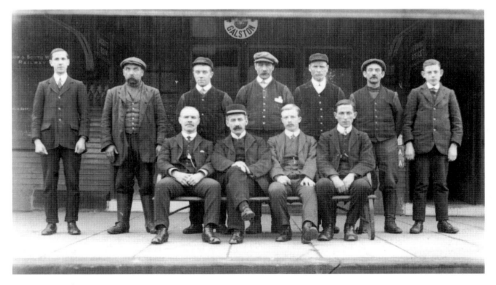

Galston Railway

The railway companies were big employers. In the days of G&SWR, a whole team of men and boys would look after a relatively small station like Galston. There is no station now, and no railway either.

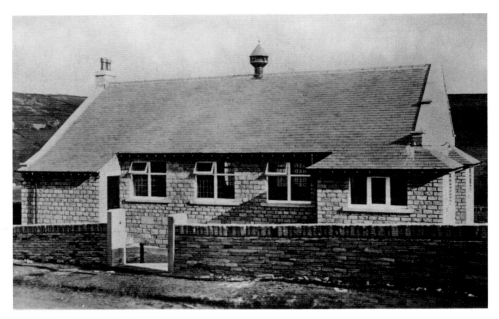

Gatehead

Not far from this small village on the edge of Kilmarnock is the disused, but restored, Laigh Milton Viaduct, recognised as the world's oldest railway viaduct. It was built from local stone for the Kilmarnock and Troon Railway, which opened in 1812.

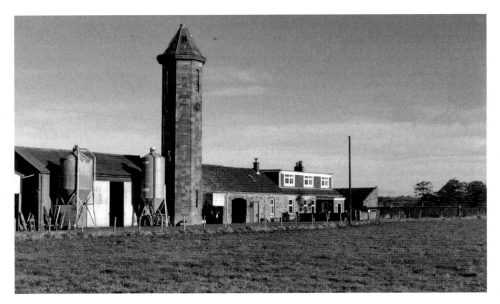

Girgenti

The farm here is near the hamlet of Torranyard. The present buildings were created using stone from the earlier Girgenti House. The farm has a distinctive tower with an octagonal roof. The story goes that the owner had a strong belief that after death he would return to the farm as a bird and he had the tower built so he would have a comfortable place to which he could fly.

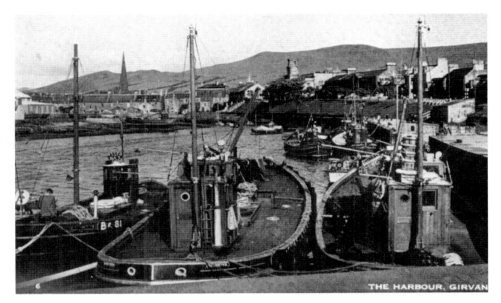

Girvan

Like many Ayrshire coastal communities, Girvan was first developed because it was a suitable location for a fishing port. It became a burgh in its own right in 1668. Girvan is largely unspoiled by the trappings of modern commercialism and it retains interesting nineteenth and early twentieth century architecture.

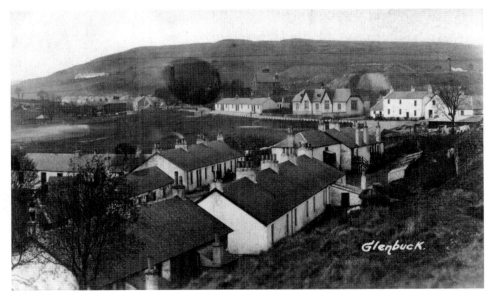

Glenbuck

Only two things really mattered in the former community of Glenbuck: coal and football. Coal, and for a time, an ironworks, provided employment, but football dominated leisure hours. For its size, Glenbuck produced an unmatched number of professional footballers, the most famous of whom was Bill Shankly.

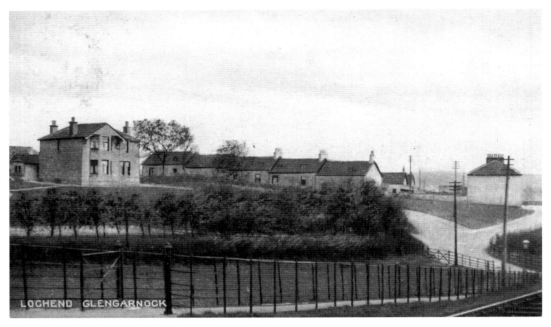

Glengarnock

The village of Glengarnock owes its origins to the establishment of the Glengarnock Ironworks, although there was a castle near here from the early fifteenth century.

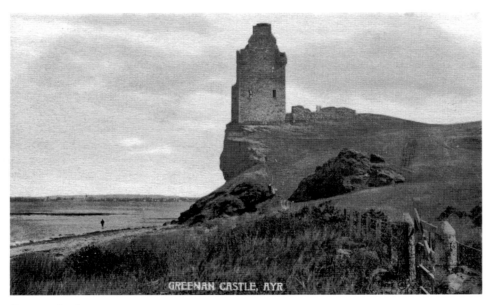

Greenan Castle

The ruin of Greenan Castle still guards the mouth of the River Doon. The original castle was built near the site of an earlier motte and bailey that marked the northern boundary of Carrick. The castle once belonged to Roger de Scalebrock, a vassal of Duncan, Earl of Carrick. By around 1582 it belonged to Thomas Davidson, who was probably succeeded by the Kennedy family of Baltersan.

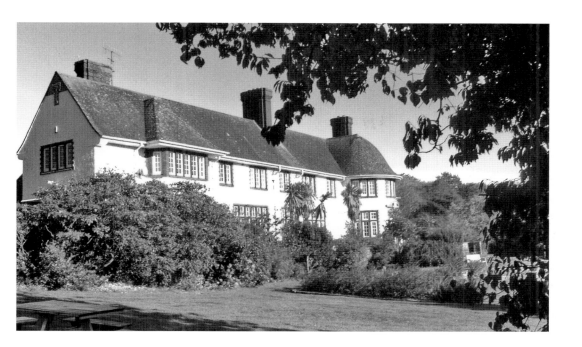

Above: **Hansel Village**

Now simply called Hansel, Hansel Village is a group of sheltered houses in the grounds of the magnificent mansion house of Broadmeadows near Symington. This was Scotland's biggest private residence when it was built at the start of the 1930s. When it came up for sale in 1961, it was bought to create Hansel Village, a centre initially created to help six girls with Down's syndrome. Hansel now provides care for more than 100 vulnerable people in a rural environment.

Right: **Hunterston**

The ancient duelling tree at Hunterston may or may not have been the venue for local duels, but the tree was a popular meeting place, so much so that part of it was cut out and a bench was placed inside it. It then became known as the Resting Tree. Eventually the tree died, but an oak was planted in 1985 to replace it.

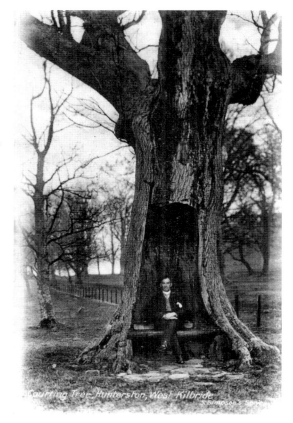

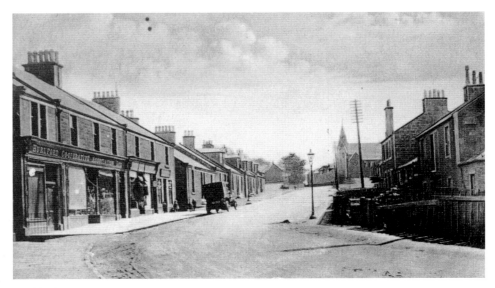

Hurlford

This East Ayrshire village became established as a collection of miners' cottages, for there was coal and ironstone to be mined here. Hurlford became home to an important iron foundry and a large propeller near the village cross is a reminder of the area's industrial heritage. Hurlford was also an important railway centre.

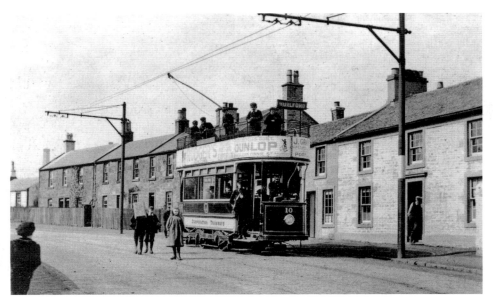

The Hurlford Tram

Even at the start of the twentieth century, the position of Hurlford and Crookedholm as communities separate from Kilmarnock was under serious threat. While there was employment on the railway, in the coal industry and in the ironworks, the commuter traffic between Kilmarnock and Hurlford was sufficient to persuade the powers-that-be to include Hurlford in Kilmarnock's tram system.

Irvine

This North Ayrshire town is an ancient burgh that grew up around the mouth of the River Irvine. Shipping, fishing and shipbuilding have all been important at various times. It was made a burgh in the twelfth century and a royal burgh in 1371. The novelist and satirist John Galt (1779–1839) was born here. Designated one of Scotland's New Towns in the 1960s, the town soon expanded to include neighbouring communities such as Kilwinning, Dreghorn and Springside. Its New Town status, supported by government subsidies, helped to attract a lot of new industry to the area.

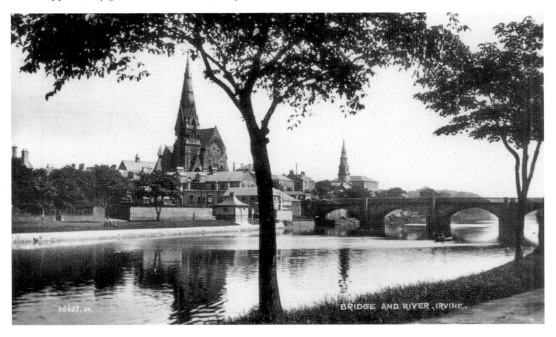

BRIDGE AND RIVER, IRVINE.

98627. Jv.

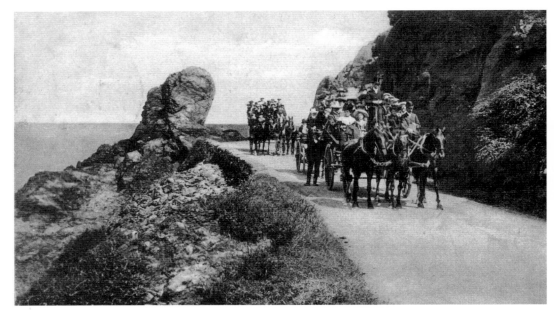

Kennedy's Pass

Most drivers who travel along Kennedy's pass near Lendalfoot give no thought to the effort that went into building this section of road. The road once climbed steeply into the hills, but in 1831 T. F. Kennedy of Dalquharan started building a lower road by blasting his way through the hard rock. It has been widened several times since.

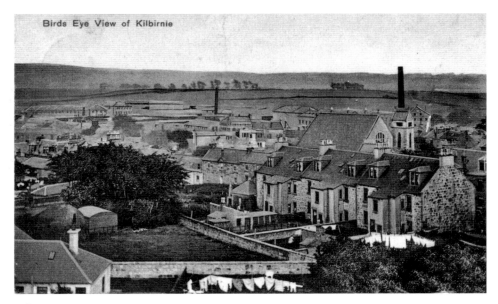

Kilbirnie

At the end of the eighteenth century Kilbirnie consisted mostly of a few scattered homes, but once a mill had been established, gradually people began to move into the area and the town we know today began to be developed.

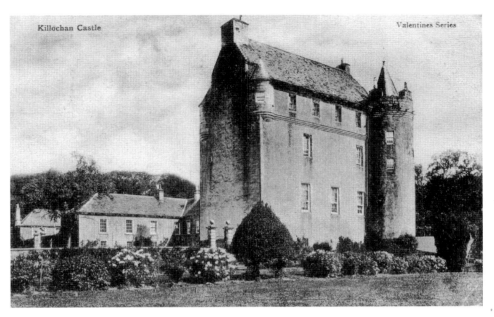

Killochan Castle

Valentines Series

Kilochan Castle

Work on the construction of Kilochan Castle started on 1 March 1586, according to an inscription above the entrance. The spectacular castle sits on the bank of the River Girvan, about three miles from the town.

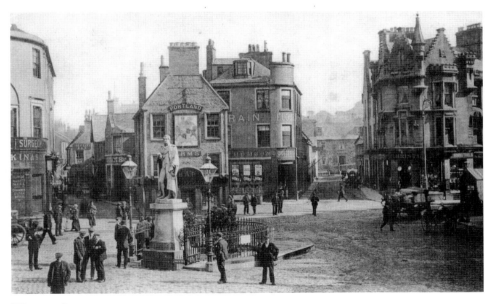

Kilmarnock

This ancient town was little more than a large village until the Industrial Revolution. The Kilmarnock and Troon Railway had a timetabled passenger service from 1812. The town also produced several world-beating companies and products such as Andrew Barclay locomotives, Glenfield & Kennedy, Saxone shoes, BMK carpets and Johnnie Walker whisky.

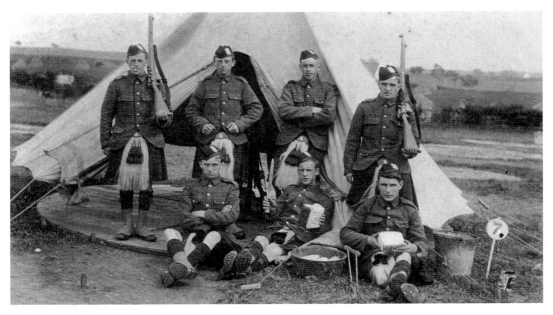

Black Watch Camp, Kilmarnock
The First World War impacted every family in the country. As young men joined up, army camps including Black Watch sprang up all over the country.

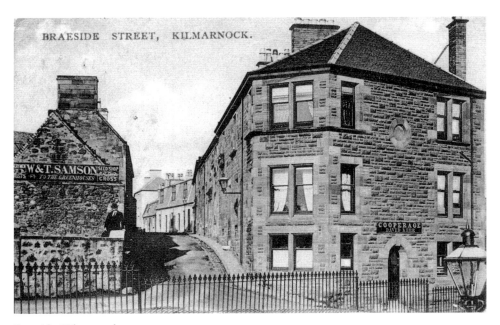

Braeside, Kilmarnock
Sometimes referred to as Braeside Street, Braeside was built on part of the steep hill of London Road. Over the years much of the steep hill was levelled off. It appears on a map of 1783 but at that time was at the edge of the town. The buildings to the right of this picture still exist today, but they are much altered.

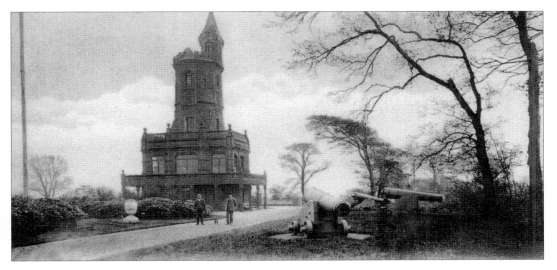

The Burns Monument, Kilmarnock

Kilmarnock people were proud of the Burns Monument in Kay Park, but in the 1980s it was closed to the public and sadly neglected by the local council. It was substantially destroyed by a fire in 2004. However, a local and family history centre and a registrars' office were built around the remains. They were opened by Alex Salmond, Scotland's First Minister, in May 2009.

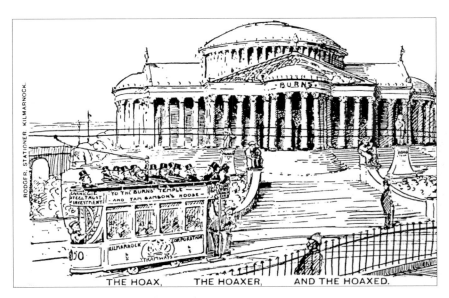

The Burns Temple Hoax, Kilmarnock

In 1904 a joke made by a local councillor got completely out of hand. Bailie William Munro sent a faked letter to the town council suggesting that Andrew Carnegie would pay for a Burns Temple to be built in Kilmarnock. The temple was to be of granite or white marble and would contain statues of Burns' associates. The offer soon became national news. But there was no such offer. Eventually Munro admitted his part in the affair and by way of apology presented Kilmarnock Infirmary with £50.

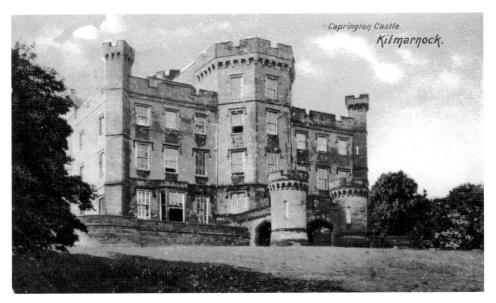

Caprington Castle, Kilmarnock

The castle sits on the edge of Kilmarnock, on the site of a much earlier castle. The earliest mention seems to be in a charter dated 1385. At one time it belonged to the Wallace family, but as early as 1462 it belonged to the Cunninghame family, who possess it today. The façade of the present castle is the work of architect Patrick Wilson, who reconstructed Caprington Castle in 1829.

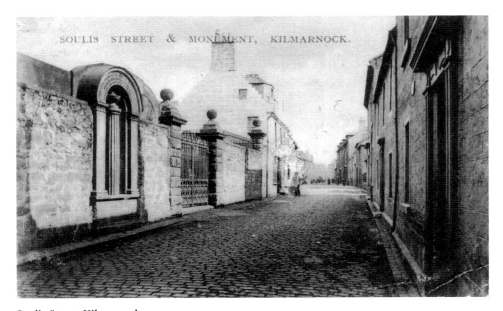

Soulis Street, Kilmarnock

This is one of the oldest streets in the town; it was once part of the main thoroughfare. It contains a memorial pillar and a plaque to one Lord Soulis, but it sheds little light on why he should be commemorated. The original Soulis Cross, presumably a market cross, is said to have been dated 1444. It was removed in 1825.

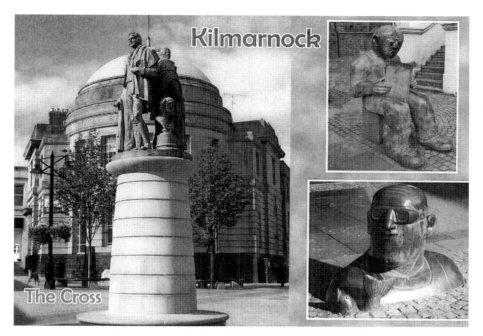

Statues, Kilmarnock
This modern postcard shows some of the town's public artworks. At the Cross there are the traditional statues of Robert Burns and his printer John Wilson. The card also shows the statue of a man reading the *Kilmarnock Standard* and a swimmer who marks the point where a river flows unseen below the main street.

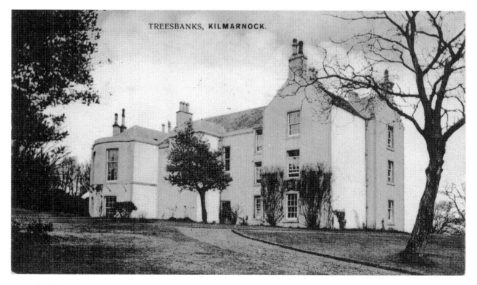

Treesbank House, Kilmarnock
This mansion off the Ayr Road at the southern extremity of Kilmarnock was originally built for Sir Hugh Campbell of Cessnock and was given to his son as a wedding present in 1672. It was substantially rebuilt 200 years later, and again in 1926.

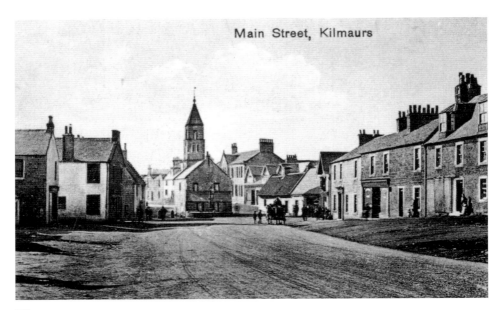

Main Street, Kilmaurs

Kilmaurs

This East Ayrshire village was made a burgh of barony in 1527. Much of the centre of Kilmaurs remains unspoilt and the centre is dominated by the sixteenth-century Jougs – the former council chamber and prison. Attached to the outside of the building is the ancient 'jougs', from which the building takes its name. A surviving neck ring and chain was once used to restrain petty crooks.

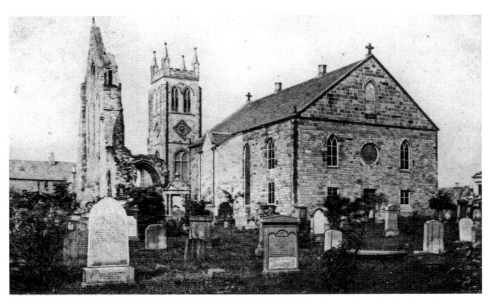

Kilwinning

In days of yore Kilwinning was the seat of power for Cunninghame, which was everything north of the River Irvine to the county border. The ancient power base was Kilwinning Abbey, part of which remains in the town centre. Kilwinning is also home to Scotland's oldest Masonic Lodge, which retains the prestigious No. 0.

Kirkmichael

This South Ayrshire village has managed to retain some of the charm of an earlier era. Weaving was once the staple cottage industry here and village retains some of the traditional weavers' cottages. The village church dates from 1787, although it was substantially rebuilt towards the close of the nineteenth century.

Kirkoswald

The old church from which Kirkoswald is said to have taken its name dates from the middle of the thirteenth century. The village churchyard has stones commemorating the various village people associated with the works of Burns. There also exists the home of one John Davidson (1728–1806), a shoemaker who appears in *Tam o' Shanter* as Souter Johnnie.

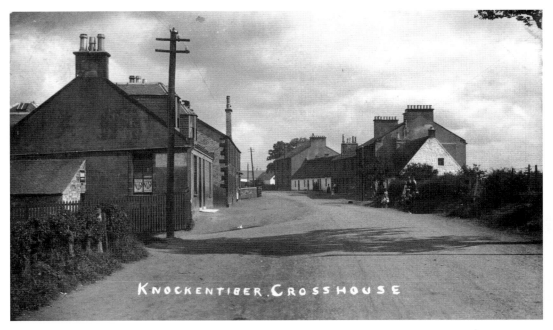

Knockentiber

This East Ayrshire village is small, but expanding. Like so many other communities in the area, Knockentiber was founded on mining. Coal, stone and clay were all mined here. The last remains of Busbie Castle were removed from the village in 1952.

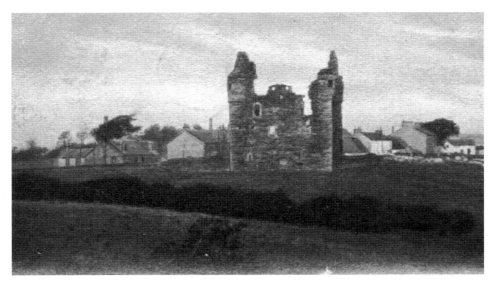

Busbie Castle, Knockentiber

The last remnant of this castle at Knockentiber was demolished in 1952 amid fears that the ruin might be unstable. The most substantial part of the building probably dated from the end of the sixteenth century, although the first building on the site was constructed at the end of the fourteenth century.

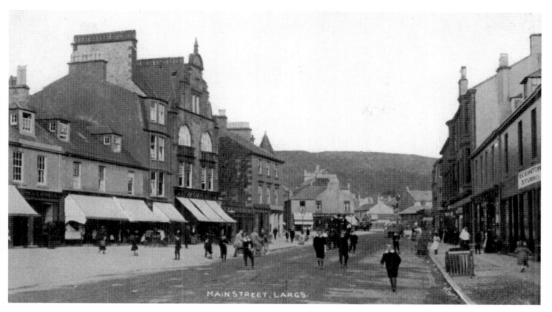

Largs

When workers in the towns and cities started to get time off, Largs became popular as a seaside resort and as a port for trips on the Clyde. It remains popular with day-trippers. Kelburn Country Park and the Vikingar Centre are the most popular attractions. Largs also has some enchanting names, such as the Gogo Burn and the Noddle Bridge.

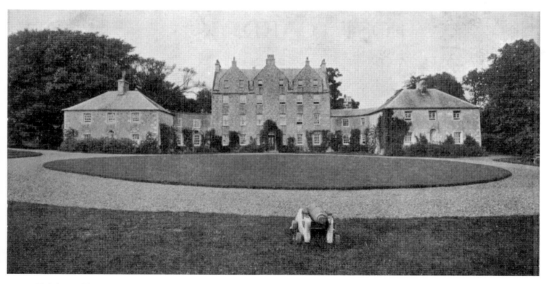

Brisbane House, Largs

This house in Largs was built in 1636 and was demolished in 1942. It was the birthplace of Sir Thomas Brisbane in 1773. He was a soldier and in 1821 was made governor of New South Wales. He was the first astronomer to chart the stars of the southern hemisphere. The city of Brisbane in Queensland is named after him.

The Ferry, Largs

In the days when steam ships took thousands of visitors 'doon the watter', Largs was an important stopping point. Today the Largs ferry runs a continuous service to Millport on the nearby island of Great Cumbrae.

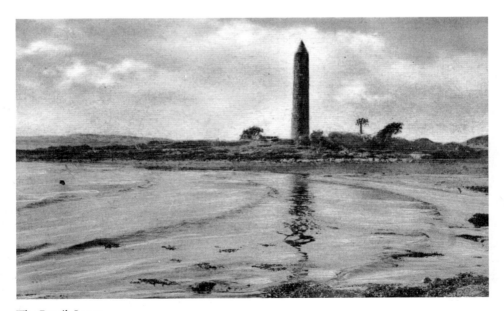

The Pencil, Largs

The tall column that commemorates the 1263 Battle of Largs, when the Vikings and the Scots clashed in a final showdown, is popularly known as the Pencil. The resulting defeat of the Vikings was the end of Norse plans to dominate Scotland.

The Shore, Largs
For many visitors, the shore was nothing without the additional attraction of fish and chips and of course ice cream. A trip to Nardini's ice cream café is still an essential part of a trip to Largs.

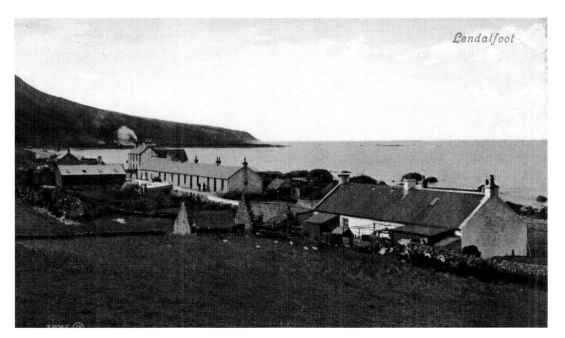

Lendalfoot
This small South Ayrshire village lies at the foot of a minor burn, the Water of Lendal. It sits in pleasant rural Ayrshire and consists of only a few houses and holiday homes.

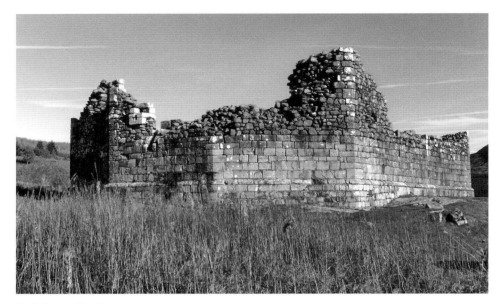

Lock Doon Castle
Ayrshire's best kept secret is unspoiled by commercialism, but it is easily accessible. The ruins are not in their original location; Loch Doon Castle used to occupy a small island. When the level of the loch was raised for a hydro-electric scheme, the castle was dismantled and reconstructed on the shore.

Lochfield Farm
Sitting in the hills high above Darvel, this rather remote farm was the birthplace of Sir Alexander Fleming. In the Scottish tradition, his primary education was in the village school, followed by secondary education in the nearest big town, in his case Kilmarnock. Fleming won a Nobel Prize for his pioneering work, which included the discovery of penicillin.

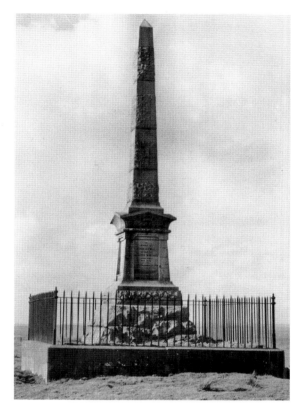

Right: **Lochgoin**

The farm of Lochgoin sits on the edge of the bleak Fenwick Moor. It became important in Scottish history as the home of several Covenanters. The Covenanters were opposed to the principle of the monarch being the head of the Church of Scotland, maintaining that the only true head of the church was God. They were brutally oppressed and many were executed for their beliefs.

Below: **Loudoun Castle**

Loudoun Castle is now a ruin. In earlier days it was said to be one of the most magnificent castles in Scotland. It was the ancestral seat of the Campbell family and the birthplace of the mother of Sir William Wallace. The 3rd Earl of Loudoun was one of the 'Parcel of Rogues' who helped draft the Treaty of Union in 1707 and sold Scotland's independence for English gold.

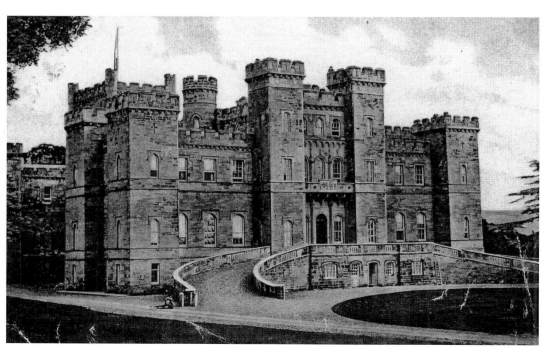

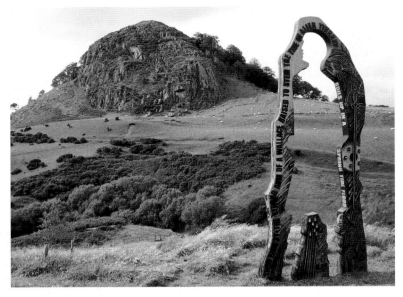

Loudoun Hill

Before there were people in Ayrshire there was the landscape. One prominent feature is Loudoun Hill, near Darvel. It is an ancient volcanic plug. The Romans recognised the significance of the site and built a fort here. The English also recognised its importance, but their army of occupation lost battles to both Wallace and Bruce here. Today the *Spirit of Scotland* sculpture commemorates Wallace's heroism.

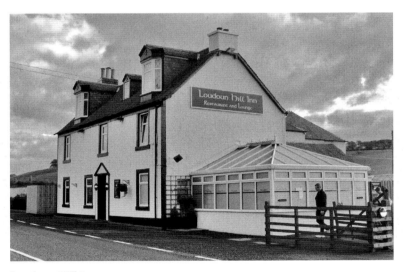

Loudoun Hill Inn

The inn's rather isolated location on a main road near the boundary of Ayrshire and Lanarkshire means that it has long been popular with travellers. Today it includes a café, a museum exhibition and a shop. From the café visitors have magnificent views of the Ayrshire landscape, including nearby Loudoun Hill.

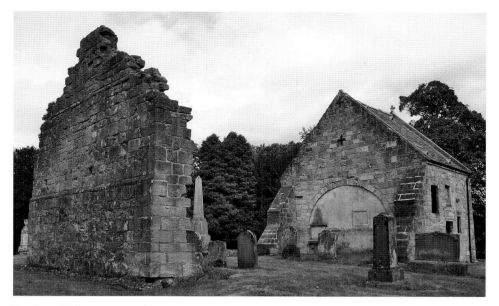

Loudoun Kirk
The old kirk stands isolated in a wooded area off a back road. It was founded in 1451 and served those who lived and worked on the Loudoun estate. There are several locally important gravestones in the surrounding kirkyard.

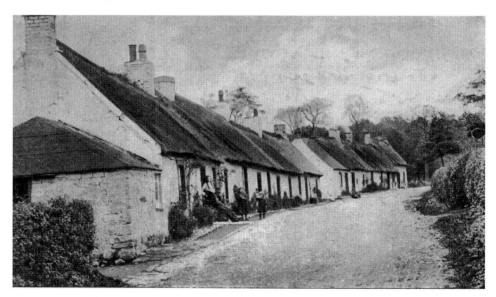

Loudounkirk
The little community of Loudounkirk existed well in to the twentieth century. This row of cottages housed some of the families who worked on the Loudoun estate. In December 1941, a fire broke out in the castle and spread rapidly through the building. The family escaped uninjured but the building was damaged beyond repair and soon abandoned. Work on the estate dried up and the cottages were later demolished.

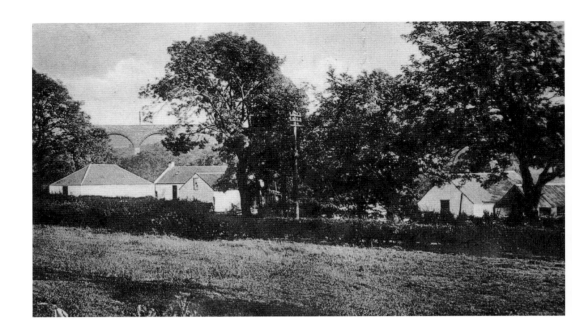

Above: **Lugar**
As with so many similar places, the central feature of this small East Ayrshire community is the church, built in 1867. The parish war memorial is in the churchyard and commemorates not only those who died in the First World War, but also those who served their country and survived.

Opposite: **Lugton**
This East Ayrshire hamlet sits close to the boundary with Renfrewshire. Lime was found in abundance in the area and the community grew up around the lime kilns and smelting works.

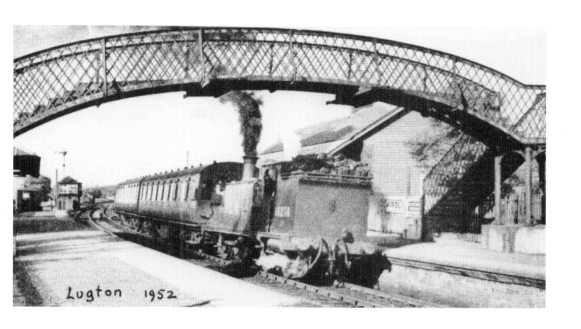

Lugton 1952

Dunlop Road Lugton

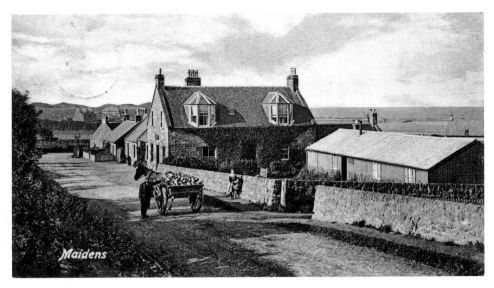

Maidens

More properly called The Maidens, this coastal village is set on some of the most splendid beaches in the country. For many years the villagers scraped a frugal living from the land and from the Firth of Clyde. The area has long been popular with visitors and a great deal of the area is still devoted to caravan parks.

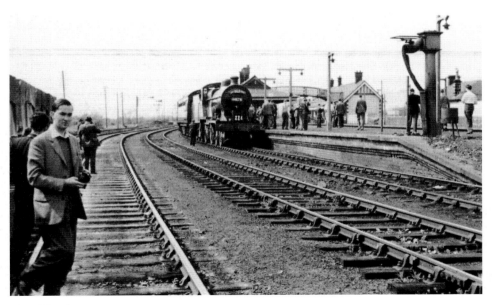

Mauchline

This East Ayrshire town's origins are lost in time, but the community was made a burgh of barony in 1510. Part of Mauchline Castle dates from the middle of the fifteenth century. Mauchline was a rural community, and became famous for small decorated wooden boxes, now known as Mauchline Ware, and for the manufacturing of curling stones, which continues today.

Right: **Statue of Jean Armour, Mauchline**
Robert Burns lived in Mauchline and today his family home is a tourist attraction. At the village cross there is a statue of his wife, Jean Armour.

Below: **Maybole**
This South Ayrshire burgh of barony grew up as a weaving community around the junctions of several roads. Dominating the town centre is the ancient Maybole Castle, which dates from the late sixteenth or early seventeenth century. The castle was the home to the Kennedy family, who were earls of Cassillis.

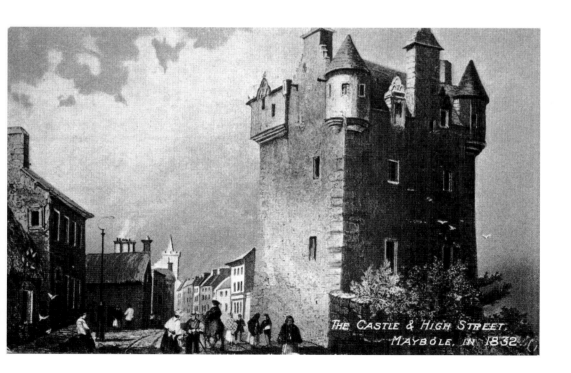

THE CASTLE & HIGH STREET, MAYBOLE, IN 1832.

Minishant

The village of Minishant sits on the busy A77 route from Glasgow to Stranraer. It is a long village, but there is not much behind the buildings that face the main road. Even so, some of the architecture of Minishant is of interest.

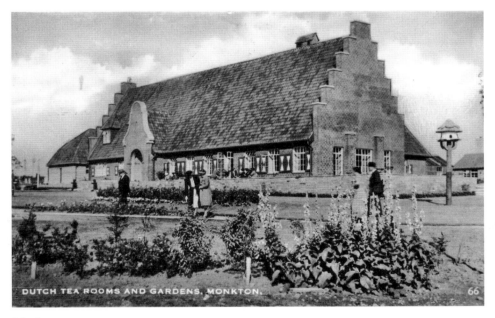

DUTCH TEA ROOMS AND GARDENS, MONKTON.

Monkton

The busy roads now bypass Monkton, so there is little through-traffic, which is a pity. According to legend Sir William Wallace had a dream in the church here and it inspired him to fight the English army of occupation. He did and set the scene that secured Scottish independence for 400 years. Just why Wallace had fallen asleep in the church is not explained.

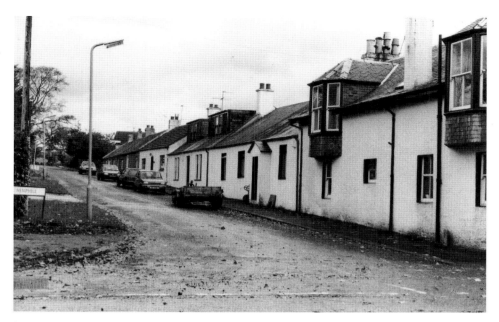

Moscow

Ayrshire has a hamlet that apparently shares a name with one of the world's great cities. But it is not quite so. There is uncertainty about the origin of the Ayrshire name. Some local wags with no knowledge of Russian geography started calling the little burn in the village the Volga and that name has stuck.

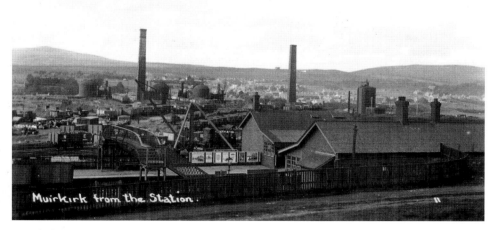

Muirkirk from the Station.

Muirkirk

The name Muirkirk is a literal description. The parish was created in 1631 and the church did indeed sit in the moor. The Industrial Revolution came here because of the village's natural resources of coal and iron. Muirkirk became home to the vast Muirkirk iron works in 1787 and the resources fed the nearby Glenbuck ironworks.

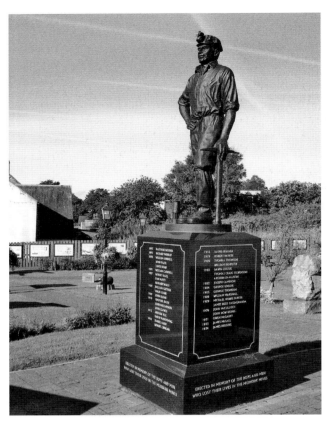

Left: **Statue of a Miner, Muirkirk**
Coal was central to the community of Muirkirk and neighbouring communities such as Glenbuck. Today an impressive statue of a miner pays homage to the people who worked in that industry.

Below: **New Cumnock**
Like so many Ayrshire communities, it was coal that was central to New Cumnock. Here in 1950 the world watched as desperate efforts were made to rescue miners trapped at Knockshinnoch Castle Colliery. The most complex mine rescue in British history saved 116 of the 129 men. A memorial commemorated the dead as well as the heroic efforts of the rescuers.

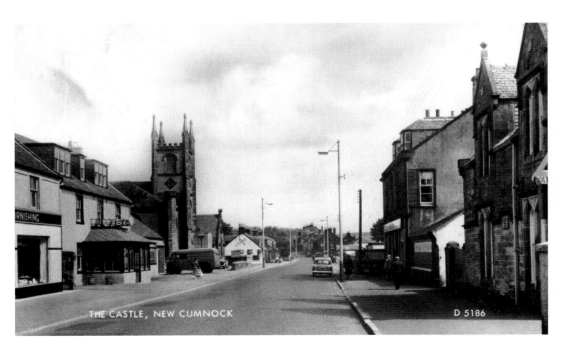

THE CASTLE, NEW CUMNOCK D 5186

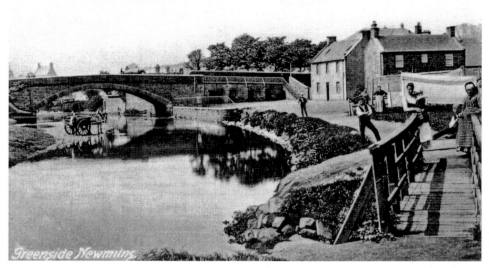

Greenside Newmilns.

Newmilns

This ancient East Ayrshire community was established as a burgh in 1490. It was the first inland burgh in the country. Newmilns folk have been at the forefront of campaigns for justice. They strongly supported the Covenanters and their campaign to free the Church from the whims of the royal family; during the American Civil War they wrote to Lincoln expressing their support for the abolition of slavery. Recently, many properties in Newmilns have been restored.

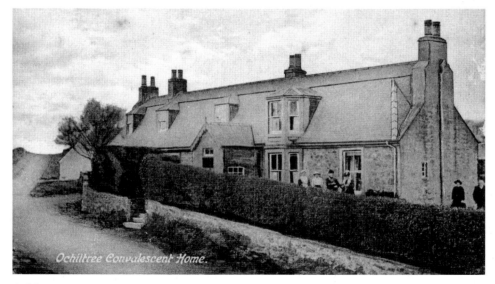

Ochiltree Convalescent Home.

Ochiltree

Ochiltree has a literary claim to fame, for it was the childhood home of author George Douglas Brown (1869–1902). In the Scottish tradition, Brown went to the village school, followed by a spell at Ayr Academy and later the University of Glasgow. He found work as a journalist in London and wrote several books, including *The House with the Green Shutters*.

Old Rome

Little remains of the original Old Rome, but it was here that Sandy Allan was brought up. He founded the Allan Shipping Line, which pioneered scheduled transatlantic passengers services and went on to spawn the Canadian Pacific Railway.

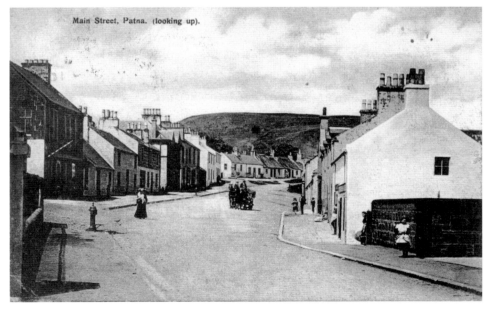

Patna

Much of Patna consists of post-war council housing, built for the families of miners displaced when several villages of much older housing were cleared.

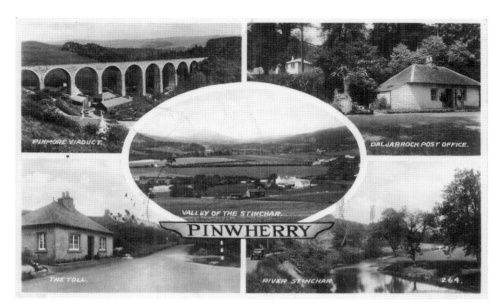

Pinwherry

A fairly typical village of rural South Ayrshire, Pinwherry's growth was based on the agricultural needs of its inhabitants. The village still has the ruins of a castle built for the Kennedy family in around 1600.

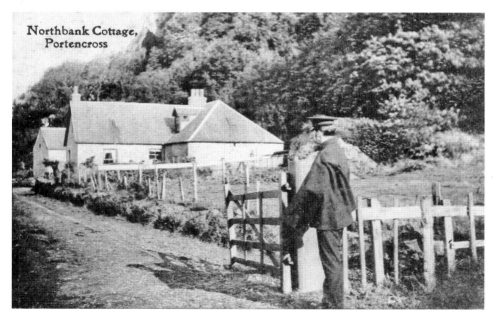

Portencross

In ancient times the bodies of Scottish kings were taken from Portencross to Iona for burial. The remains of Portencross Castle still dominate this quiet, picturesque village. In 1588 England was at war with Spain, but Scotland was not and a Spanish ship seeking refuge sank near Portencross. Cannons and other items were recovered from the sunken wreck.

Left: **Portencross Castle**
Near West Kilbride and originally called Ardneil Castle, Portencross Castle and was owned by the Ross family, sheriffs of Ayr. However, they supported Baliol and when Bruce became King of the Scots, and the castle was presented to the Boyds, the family who would later have a long association with Dean Castle in Kilmarnock. Extensive restoration work has been carried out and a programme of open days allowing public access to the building has been prepared for 2011.

Below: **Prestwick**
Several of the old features of this ancient town are incorporated in the town centre. However, it is golf that has made Prestwick famous. The area has fine course and the first Open Championship was held here in 1860.

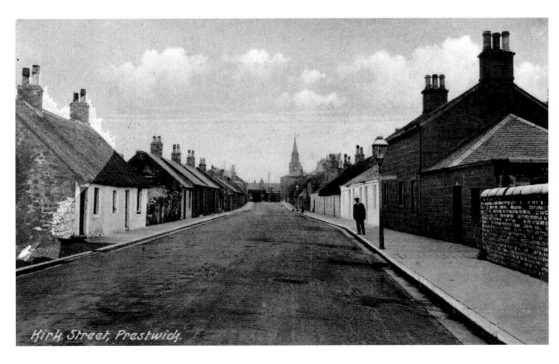

Kirk Street, Prestwick.

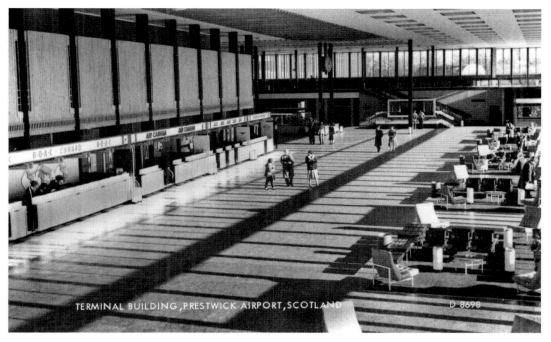

TERMINAL BUILDING, PRESTWICK AIRPORT, SCOTLAND D 8698

Prestwick Airport

One of the country's first international airports, Glasgow Prestwick has an excellent weather record and in the days before autopilots it was billed as a fog-free airport. Elvis Presley made a stopover at Prestwick while returning to the USA from military service in Germany.

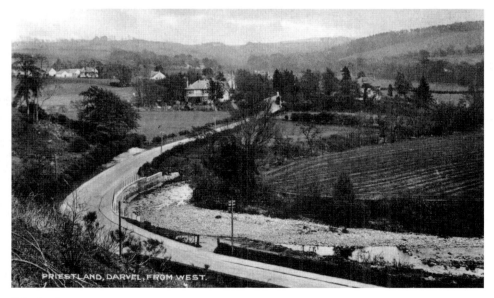

PRIESTLAND, DARVEL, FROM WEST.

Priestland

A small community at the head of the Irvine Valley and almost in the shadow of Loudoun Hill, Priestland is an ancient community close to the Lanarkshire border.

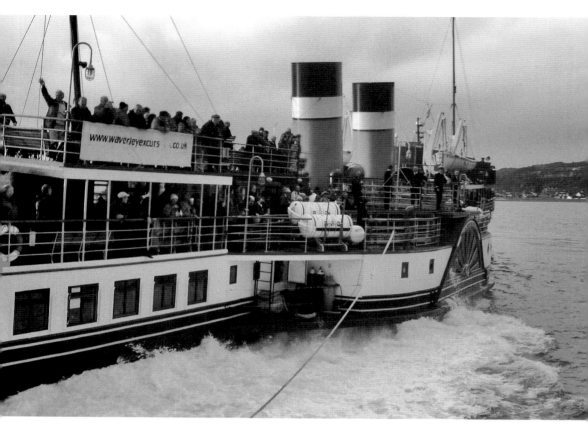

PS *Waverley*

When she made her maiden voyage in 1947, the present ship with the name *Waverley* was just one of many paddle steamers to be seen around our coast. Today this Glasgow-based ship is the last seagoing paddle steamer in the world. She makes frequent trips to the Ayrshire coastal ports and is also popular on her travels around the rest of Britain.

Opposite: Riccarton

This East Ayrshire town has been absorbed into the urban sprawl that is Kilmarnock and has lost its independence. Yet Riccarton has its own proud history: the parish was the home of the Wallace family. Sir William Wallace, that great campaigner for Scottish freedom, is said to have been born in the parish of Riccarton – in the hamlet of Ellerslie.

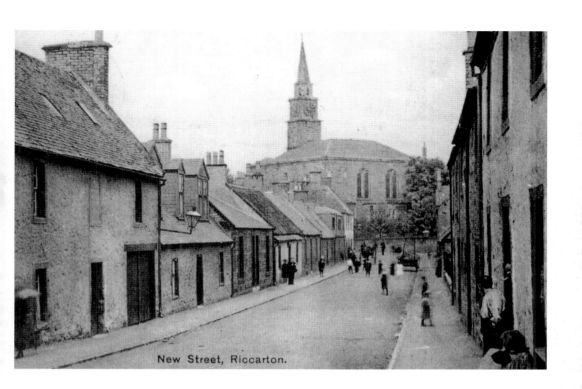

New Street, Riccarton.

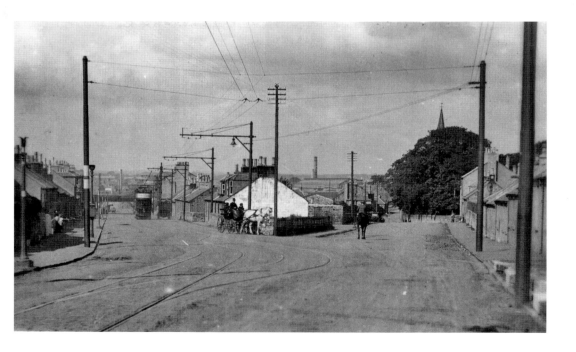

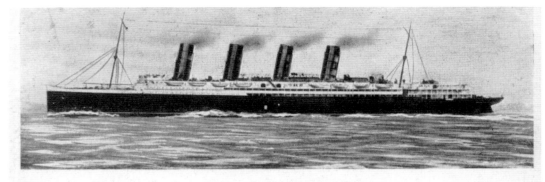

THE "LUSITANIA."

Oh Lusitania, with souls e'er so dear,
That crossed the wide ocean regardless of fear:
Tae think o' the crying—baith mithers and weans—
Oh cruel-hearted Kaiser, you should be in flames.

Oh Lusitania! Who could not but weep
For souls that perished in crossing the deep:
Though people in Berlin took pride at your fall—
The cruel-hearted Kaiser was cause of it all.

Copyright—Robert Orr, 11 Nursery Avenue, Kilmarnock.

RMS *Lusitania*

The sinking of the passenger liner *Lusitania* on 7 May 1915 shocked Britain and there was an outpouring of grief for the families of the 1,198 victims. The dead included James and Kate Barr from Kilmarnock. James was the eldest son of John Barr, a director of Glenfield & Kennedy. Robert Orr lost no time in producing this postcard.

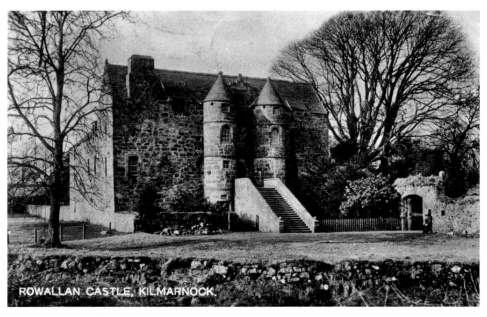

ROWALLAN CASTLE, KILMARNOCK.

Old Rowallan Castle

There are two Rowallan Castles. Old Rowallan dates from the sixteenth century. The front of the castle is dominated by a massive stairway and two ornamental turrets, though they are not the oldest parts of the castle.

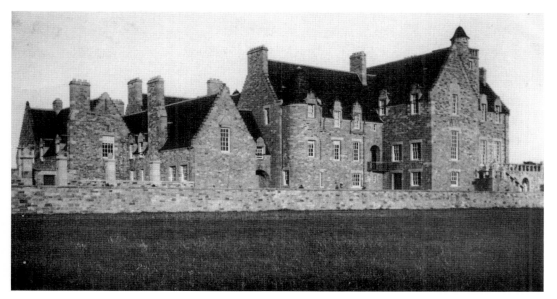

New Rowallan Castle
In 1906, construction on the New Rowallan Castle was completed for Archibald Corbett, First Baron Rowallan. Work had started in 1903, but the planned size was amended due to the death of Alice Corbett in 1902. There is a memorial to Alice Corbett on the Fenwick Moor. With the completion of the castle, the family gave Rouken Glen to the City of Glasgow.

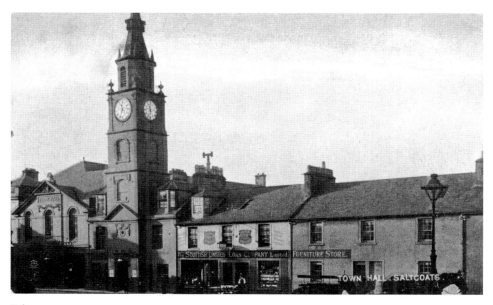

Saltcoats
The people of this North Ayrshire town once made their livings by extracting salt from the sea. Occasionally, when the tide is very low, the remains of fossilised trees can be seen on the shore nearby. In the days before overseas holidays, Saltcoats was a popular resort for Glaswegians and other holidaymakers from inland towns.

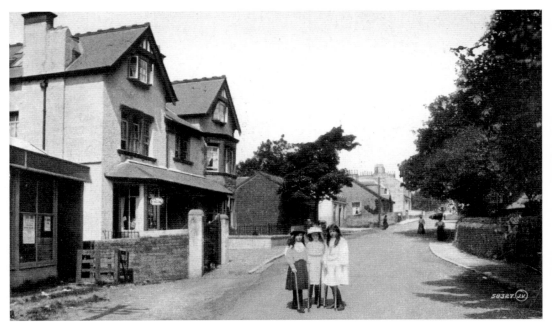

Seamill

Folk from Seamill don't like to be told that their village is part of West Kilbride. The houses, shops and hotels that form Seamill sit on sharply rising land on the coast of North Ayrshire.

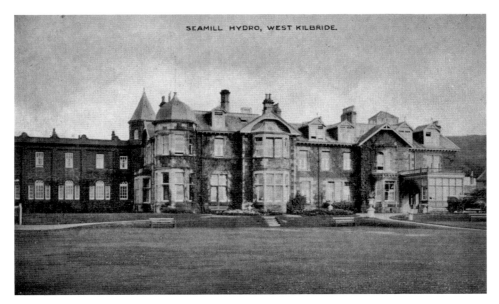

SEAMILL HYDRO, WEST KILBRIDE.

Seamill Hydro

In 1871, when Seamill Hydro was first established, it was a popular belief that the fresh air and sea water would cure most ills. This led to the establishment of hydros in many parts of the country. The Seamill Hydro today is much expanded and continues to be one of Ayrshire's most popular resorts.

Skelmorlie

The first thing anyone travelling through Skelmorlie notices is the village's striking architecture. It is a fairly modern village, dating from the middle of the nineteenth century. The first houses were built as a seaside resort for the wealthy merchants of Glasgow.

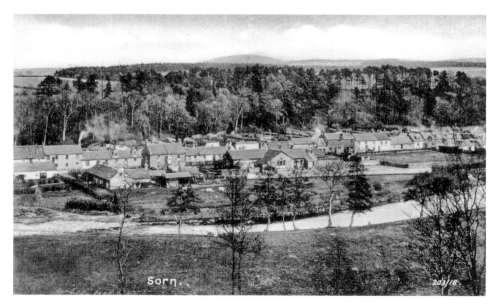

Sorn

Close to this pleasant village is Sorn Castle, which has extremely distinctive architecture. The castle and grounds are open to the public during the summer months. In Sorn, the churchyard has the grave of George Wood, who, at sixteen, was the youngest Covenanter to die during the bitter struggle for religious freedom.

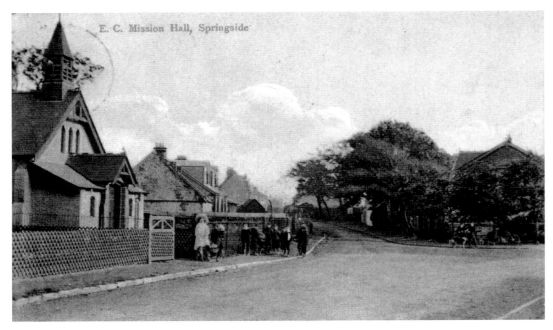

Springside

Now part of Irvine New Town, Springside has retained much of its charm. It was once part of a string of villages dominated by mining and quarrying. Springside was the birthplace of world flyweight boxing champion Jackie Paterson.

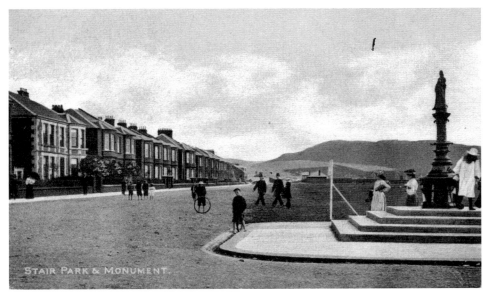

Stair

One of the main buildings in this small but vibrant community in South Ayrshire is Stair House, which was built in the seventeenth century. Stair Inn was established in 1820 as a coaching inn and is still popular today.

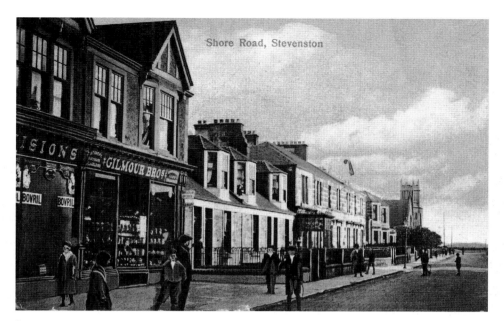

Shore Road, Stevenston

Stevenston

Joined to Ardrossan and Saltcoats, Stevenston is one of the Three Burghs. Coal mining was important here and Stevenston had one of the first deep pits in Ayrshire. It also had the first Newcomen steam engine in Scotland.

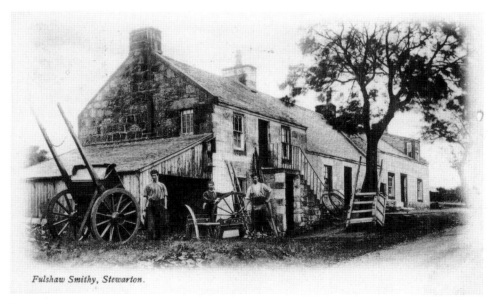

Fulshaw Smithy, Stewarton.

Stewarton

This East Ayrshire settlement relishes the description 'the Bunnet Toun'. There was great rivalry between the bonnetmakers of Stewarton and Kilmarnock. Although a bustling, modern town, much of the centre of Stewarton retains its earlier architectural charm and many of the shops remain in the hands of local families.

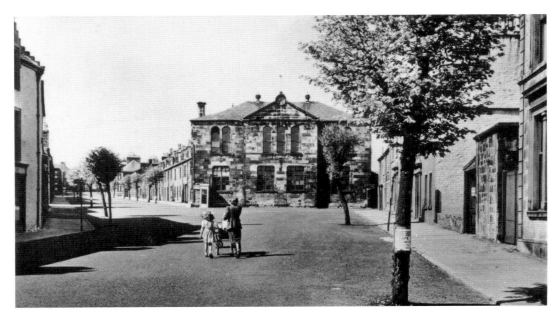

Avenue Square, Stewarton
This large burgh once looked after its own civic affairs. Some of the fine architecture of that period is still apparent today, particularly around Avenue Square.

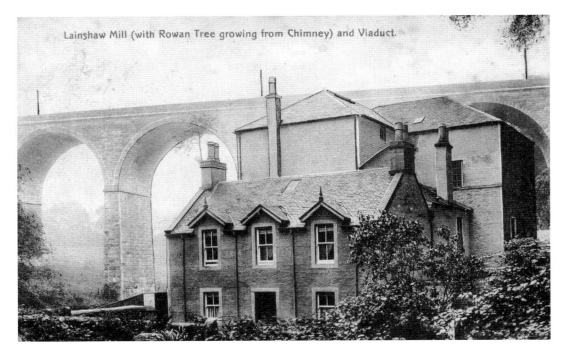

Lainshaw Mill (with Rowan Tree growing from Chimney) and Viaduct.

Lainshaw House, Stewarton
Something of a showpiece, the mansion house was built and added to over several centuries. At one time it was an old folks' home, but today it is again private residences.

Straiton

A small village that was established in the middle of the eighteenth century, Straiton retains much of its rural charm. Like most communities, Straiton has a war memorial listing the names of the local men killed fighting for king and country.

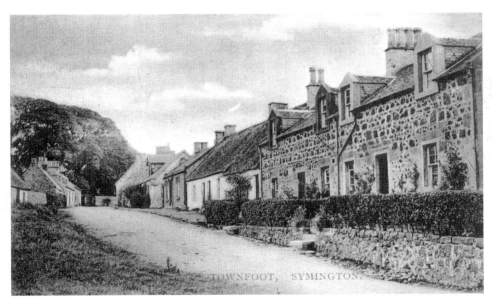

Symington

The ancient church of Symington was built in around 1160, and today it is the oldest Ayrshire church still used for worship. It was restored to something near its original look as a memorial to the men killed in the First World War. Symington was the birthplace of noted artist and historian John Kelso Hunter.

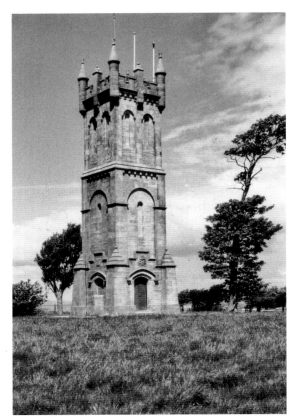

Left: **The Barnweil Monument, Symington**
Sitting on a hill near Symington, this monument was built between 1855 and 1858 to commemorate Sir William Wallace and his Ayrshire roots. It was Wallace who moulded the population into an effective resistance force to free Scotland from the tyranny of King Edward I of England. It was the first major monument to Scotland's most popular hero.

Below: **Tarbolton**
This village has several buildings of note, but the best known is the Bachelors' Club. It is now in the care of the National Trust for Scotland. It was here that Robert Burns and some of his cronies set up a club for dancing, singing and, bravely, discussing the need for political change in Scotland.

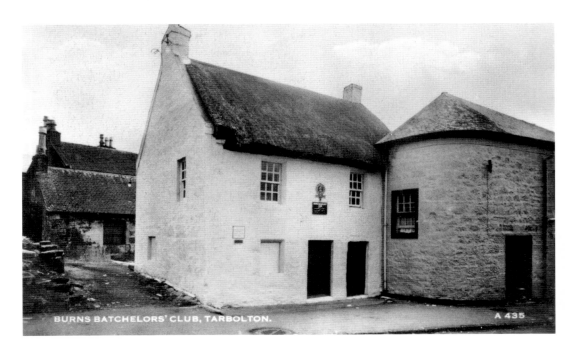

BURNS BATCHELORS' CLUB, TARBOLTON.

A 435

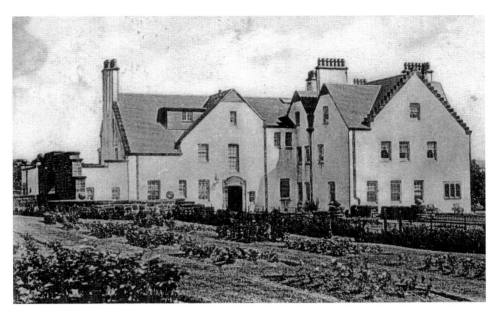

Templetonburn
This mansion house near Crookedholm was completed in 1901 and was held up as a fine example of the architectural skills of James Hunter. Unfortunately, the building was eventually destroyed by fire.

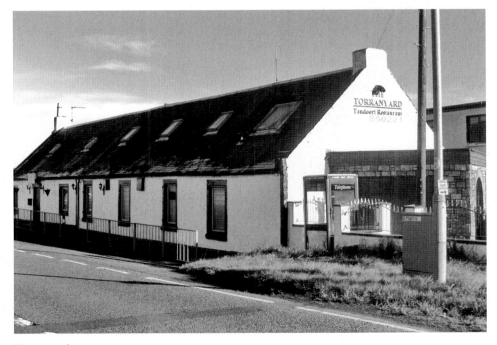

Torranyard
This North Ayrshire hamlet set among several farms is close to the ruin of Auchenharvie Castle.

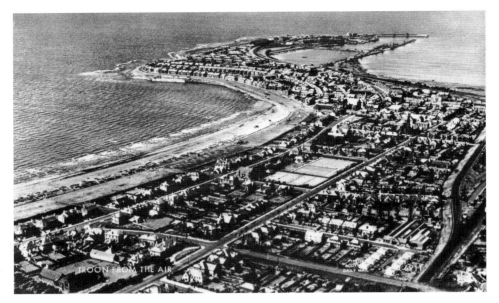

Troon

The town of Troon was built at the start of the nineteenth century by the local landowner as part of a four-point plan. The plan called for a harbour, a new town, major improvements in Kilmarnock, and a railway to link between Kilmarnock and Troon. That railway had a timetabled passenger service from the summer of 1812, one of the first such services in the world.

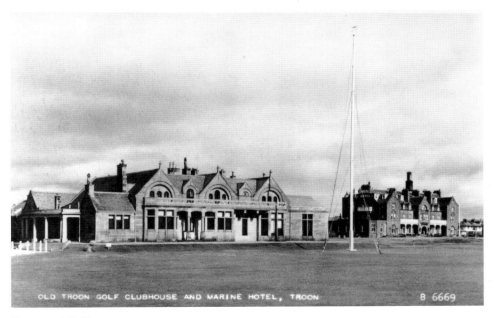

OLD TROON GOLF CLUBHOUSE AND MARINE HOTEL, TROON B 6669

Troon and Golf

More than anything else, Troon is today known for golf and there are half a dozen courses around the town, including Royal Troon and Old Troon. The Open Championship has been held at Troon on several occasions.

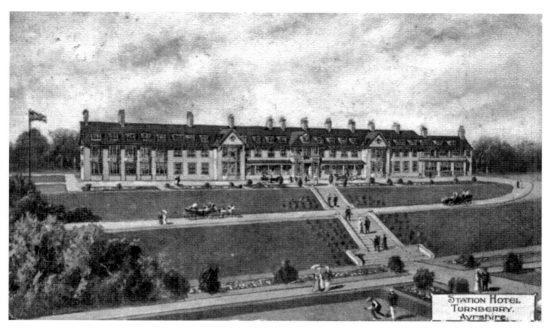

STATION HOTEL
TURNBERRY.
Ayrshire.

Turnberry

This fishing hamlet would probably have remained obscure had it not been for the development of a fine hotel by G&SWR. Turnberry is also famous for golf and the local lighthouse is something of an icon.

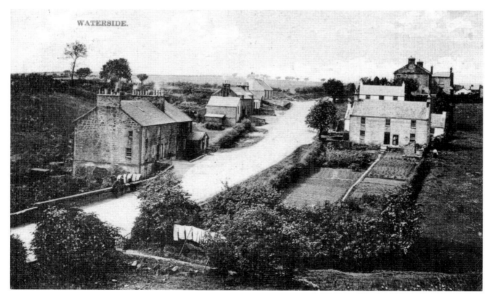

WATERSIDE.

Waterside

The hamlet of Waterside is part of the parish of Fenwick. It sits on the edge of the Fenwick Moor and on the edge of Whitelee Forest, now home to the biggest onshore windfarm in Europe. In former times the village had its own creamery, post office, shops and school.

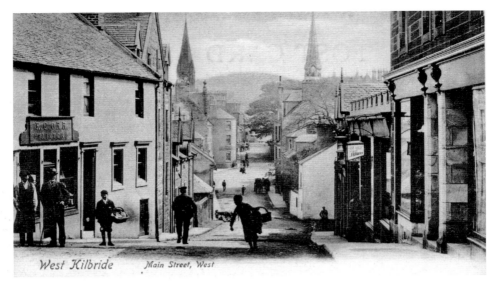

West Kilbride Main Street, West

West Kilbride
Like most communities in Ayrshire, the people of West Kilbride have much to be proud of and several sons of the village who have made their name on the world stage are buried in the kirkyard. The main street in the village retains much of its early architecture.

Bibliography and Acknowledgements

Adamson, Archibald, *Rambles through the Land of Burns* (Dunlop & Drennan, 1875).
Ayrshire Guide (Ayr County Council, 1953).
Ayrshire Notes (Ayrshire Federation of Historical Societies).
Close, Rob, *Ayrshire and Arran: An Illustrated Architectural Guide* (Royal Incorporation of Architects in Scotland, 1992).
Dunlop, Annie, *The Royal Burgh of Ayr* (Oliver & Boyd, 1953).
Hume, John R., *The Industrial Archaeology of Scotland, Part 1: The Lowlands and Borders* (B. T. Batsford, 1976).
Hume, John R., *Vernacular Building in Ayrshire* (Ayrshire Archaeological and Natural History Society, 2004).
Love, Dane, *Ayrshire: Discovering a County* (Fort Publishing, 2003).
Mackay, James A., *Burnsiana* (Darvel: Alloway Publishing, 1988).
Mackay, James A., *Kilmarnock* (Darvel: Alloway Publishing, 1992).
Macintosh, John, *Ayrshire Nights Entertainment* (Dunlop & Drennan, 1894).
Malkin, John, *Pictorial History of Kilmarnock* (Darvel: Alloway Publishing, 1989).
Steele, John & Nora, *The American Connection to the Sinking of HMS Dasher* (Steele, 2010).
Strawhorn, John, *Ayrshire: Story of a County* (Ayrshire Archaeological and Natural History Society, 1975).
Strawhorn, John, *The History of Irvine* (John Donald, 1985).
Strawhorn, John, *The History of Ayr* (John Donald, 1989).
Wilson, M., *The Ayrshire Hermit* (Alfred Chas, 1875).

Also, the files of the *Ayrshire Post*, the *Irvine Herald* and the *Kilmarnock Standard*.

Thanks go to the library staff of East Ayrshire Council, North Ayrshire Council and South Ayrshire Council. Special thanks to the staff at the Burns Monument Centre in Kilmarnock. Thanks also to the Friends of Portencross Castle and the National Trust for Scotland.